# DIRECTOR'S CHOICE

## THE NATIONAL GALLERY LONDON

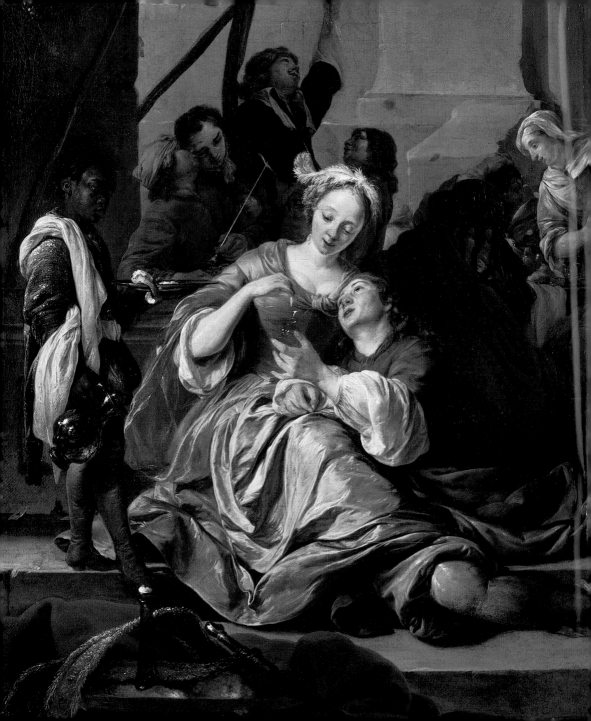

# DIRECTOR'S CHOICE

## *Nicholas Penny*

# THE NATIONAL GALLERY LONDON

THE
NATIONAL
GALLERY

SCALA

# INTRODUCTION

MANY OF US NOW LOOK at reproductions of pictures on screens, where the excitement lies in 'zooming in' on a detail. Apart from the excessive prestige this gives to the artists who were most deft at painting eyelashes, or diligent in delineating separate bricks in distant churches, it encourages us to forget that it is not the flight into the picture but the journey back, from part to whole, which gives us most pleasure when looking at a real painting in a gallery. It is the same when we are reading poetry: an apt image or a striking line is delightful to encounter in isolation, but the more profound pleasure comes from a recognition of how it was prepared for and how it resonates, an understanding of how it is made more apt or more striking because of what comes before and what comes after.

My method in writing about the paintings I have chosen for this book has usually been to draw attention to details and some of the more abstract qualities (colour, line, form, space); then I have tried to indicate how these relate to the composition of the whole and are inseparable from the subject. I began by closing my eyes and taking a mental stroll through the National Gallery, pausing to note which pictures had left a sharp enough image in my memory for me to start making notes about them. Details usually came to mind. Sometimes these seem to epitomise the whole painting – for example, the outstretched arm of Tiepolo's Venus (see page 42) or the knees of the nude in the lower left-hand corner of Rubens's sketch (see page 41). I was also occasionally distracted by a detail – the cat in Hogarth's portrait of the Graham children, for example – which is an exceptionally fine part of a painting that I do not otherwise admire very much.

The book was not written from an autobiographical point of view. Had it been, it would have consisted almost entirely of Italian paintings:

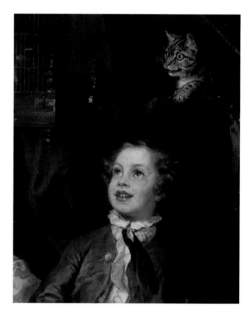

William Hogarth, *The Graham Children* (detail), 1742

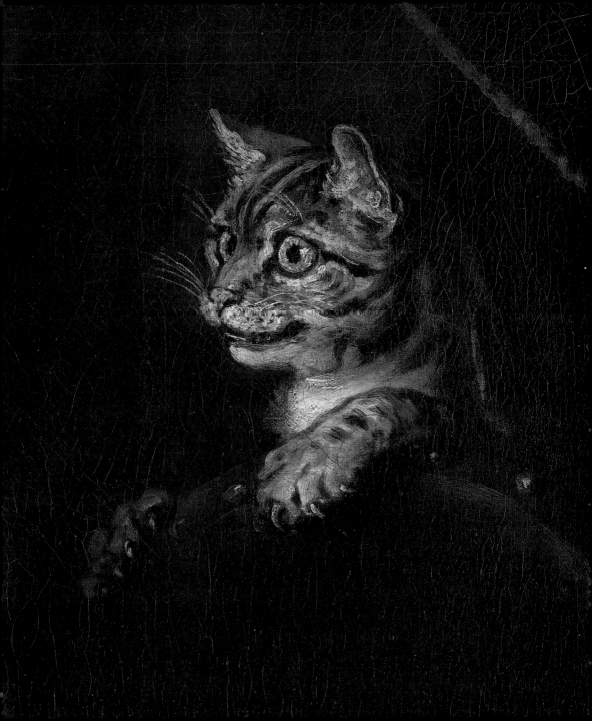

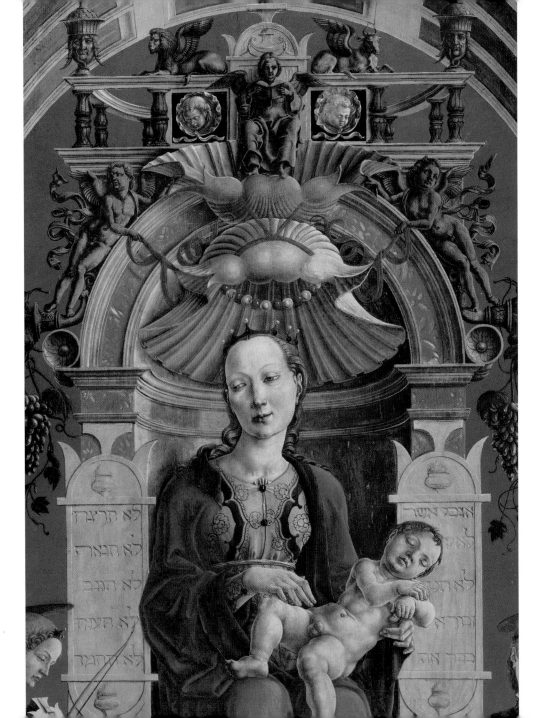

the early Renaissance Florentine paintings that I loved when I was first taken to the National Gallery as a child, aged about eight, above all Botticelli's *Venus and Mars*, which I liked to copy (something frowned on at school), and the Ferrarese pictures which amazed me when I was about 16. I do not recall anyone trying to make pictures by Cosimo Tura relevant to the twentieth century, and for me they seemed wonderful precisely because they were so alien. It fascinated me to imagine the circumstances in which it might seem natural to paint people as if they were made of glass and dwelt among sea creatures fashioned in metal. I would also have included paintings by Moroni and Lotto because I studied them for my catalogue of the paintings in the National Gallery from Bergamo, Brescia and Cremona, and more of the Venetian artists who feature in my second catalogue.

The works selected here come from all parts of the National Gallery, and from the fourteenth to the early twentieth centuries. I have included no still-life paintings and few 'pure' landscapes, and this reveals a preference for paintings of people. I regret the absence of one of Claude's paintings, but they tend to get confused in my recollection and it would be hard to select one in particular. I have not chosen anything by Caravaggio or Vermeer. This reflects some irritation at the volume and nature of the publicity they currently enjoy: indeed, I cannot help feeling that their reputations would be best served by a prohibition on any writing about them for a decade or so.

I have in any case included only two paintings that would generally be counted among the 20 or so greatest paintings in the National Gallery. These are the '*Rokeby Venus*' by Velázquez and the *Bathers at Asnières* by Seurat, and in both cases I have concentrated on details. It is somewhat paralysing to think how much has already been written about these pictures, but something else – perhaps it is the rather daunting idea of canonical status – makes me hesitate to select the *Wilton Diptych*, *The Arnolfini Portrait* by Jan van Eyck, *The Battle of San Romano* by Uccello, Piero della Francesca's *Baptism*, *The Virgin of the Rocks* by Leonardo, *The Ansidei Madonna* by Raphael, Titian's *Bacchus and Ariadne*, *The Ambassadors* by Holbein, *The Family of Darius* by Veronese, Rubens's '*Chapeau de Paille*', *The Stonemason's Yard* by Canaletto, *Whistlejacket* by Stubbs, *The Fighting Temeraire* by Turner, or Van Gogh's *Sunflowers*. The list is not a closed one, and indeed Titian's *Diana and Actaeon* has

Cosimo Tura, *The Virgin and Child Enthroned* (detail), mid-1470s

OVERLEAF: The 'Barry Rooms' (a wide angle view of Room 36, with Rooms 38 and 40)

recently been added to it. A list of the 'greatest' paintings inevitably intersects with one including the most popular, some of which do not enjoy quite the same level of critical admiration: *Christ before the High Priest* by Honthorst, *The Avenue at Middelharnis* by Hobbema, *The Execution of Lady Jane Grey* by Delaroche, *Surprised!* by Rousseau. Here too the list is not closed and I notice that Gallen-Kallela's haunting *Lake Keitele* has recently qualified – at least by the criterion of postcard sales.

The paintings are arranged here, as they are in the Gallery itself, in approximately chronological order, although there are a few exceptions. I have placed Duccio's *Annunciation* next to Titian's *Noli me Tangere* because they seem to me to be the two finest paintings in the Collection of two figures engaged in a dramatic dialogue, the first supported by architecture, the second by landscape. I have also deliberately grouped three paintings that are, in different ways, sculptural, and three that involve women considering their reflections (in water or in a mirror), as well as three compositions intended for a ceiling. Some contrasts are also intended – that, for example, between Raphael and Correggio, or between Poussin and Weenix – and I am pleased that portraits by Reynolds and Goya happen to fall next to one another. We can obtain similar effects in the hanging of pictures – that is, similar, but not the same, for no one of these conjunctions would really be happy on the wall.

THE NATIONAL GALLERY is situated in the centre of London, occupying the north end of Trafalgar Square, the traditional site for popular protest and revelry but also a great ceremonial – indeed, imperial – space, now regularly given over to commercial events by the officials responsible for its care. But it is not impossible to imagine the north end converted into a magnificent and convivial formal garden that would be more agreeable for the more than four million people who visit the Gallery every year. There are days when some of the rooms are uncomfortably full, but even on those days visitors will find themselves able to contemplate some of the greatest paintings in tranquility. The Victorian and Edwardian interiors feature marble door surrounds and richly modelled and partially gilded plaster vaults. It is only during the last 30 years that those interiors have been liberated from later attempts to cover them up. With the restoration of this palatial style it has been possible to escape from the whims of

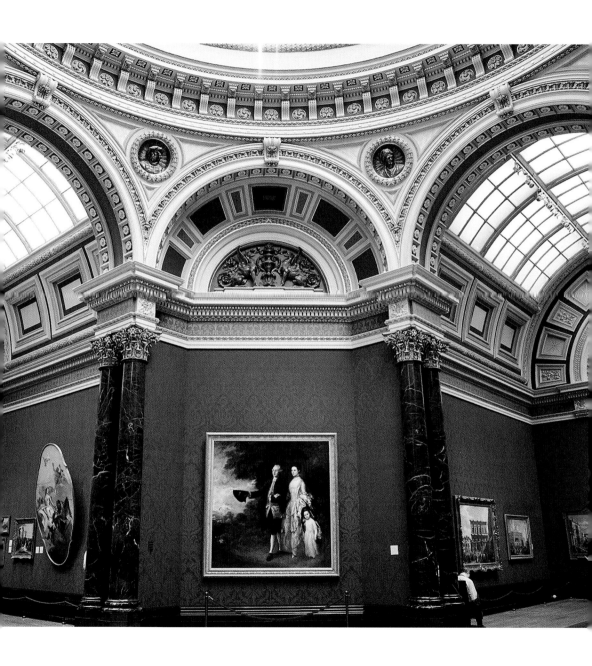

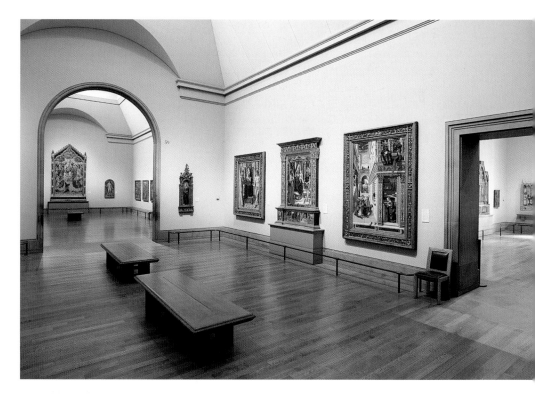

contemporary design and to hang the paintings against the sort of richly coloured textiles that were in favour when these interiors were built.

The opening of the Sainsbury Wing in 1991, not long after I came to the National Gallery as a curator, not only greatly increased the space available for hanging paintings but also improved the visitor's experience in several important respects, of which the least obvious but perhaps most important was the provision of galleries for the early Renaissance paintings which were markedly different in style from those in the Wilkins building. This encouraged visitors to make a separate visit to the Sainsbury Wing rather than try to see everything in one. It also meant that the earlier paintings, the majority of them made for ecclesiastical settings and none for opulent picture galleries, would be shown against plainer walls but still in an exalted setting.

The Sainsbury Wing
(Room 59 looking into Room 63,
with 55 on the right)

The original building by Wilkins was paid for by parliamentary grant, although some of the galleries within were built – and many of them have been restored and embellished – by private benefactions. The Sainsbury Wing was the gift of the three brothers after whom it is named. The paintings were acquired both with public funds and by private gift or bequest. This has always been the case and it applies to many of the works in this anthology – for example, the Guercino bequeathed in 1851 by Holwell Carr (see pages 48/49) and the Monet bequeathed by Simon Sainsbury (also one of the donors of the Sainsbury Wing) in 2006 (see pages 74/75). That the National Gallery is still able to buy works of the highest quality is due to the endowment established by Sir Paul Getty; to enlightened legislation that provides some incentives and benefits to those who bequeath or sell to a public collection; to the Art Fund; and to the Lottery and National Heritage Memorial Funds, which have replaced the special treasury grants upon which the Gallery once chiefly depended.

It would be fair to claim that for all the tensions in this dependence on public and private support it has helped the Gallery to remain largely free of the inappropriate political influence that has plagued many of the great state institutions of continental Europe. Responsibility for the Gallery is vested in its trustees, to whom the director reports. These have included, especially in the early years of the Gallery's existence, and in recent years, some of its greatest private supporters and benefactors. What guarantees continuing private support is confidence that the institution is one that will endure because of both the investment of previous generations in its success and the affection of all the people who not only visit but revisit – and for whom this book is intended.

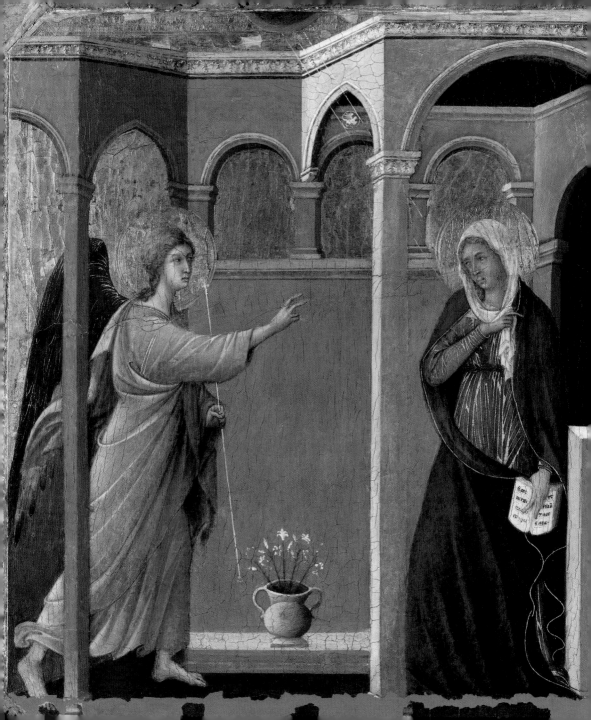

Duccio
Siena *c.*1255–1318/19 Siena

### *The Annunciation*, 1311

Egg on poplar, 43 x 44 cm
Purchase, 1883
NG1139

THE YEAR IN MANY parts of Christian Europe began on the feast day of the
Annunciation when the Virgin Mary was greeted by the Archangel Gabriel
and miraculously impregnated by the Holy Spirit in the form of a dove. The
subject had been treated by sculptors, goldsmiths and book illustrators for
centuries with the sort of open architectural setting we find in this paint-
ing by Duccio, but never to such effect. The movement here is dramatised
by the empty centre of the composition and enhanced by the architecture,
for instance the way the arch leaps up behind and above the Angel Gabriel's
hand, and the verticals that contrast with the Virgin Mary's twisting pose, or
the arch that continues the sweeping line of her cloak. Some of the gilding
in the painting has been meticulously tooled (notably the punched pattern
on the burnished disks of the haloes), but on the Virgin's rose-coloured
dress the splintered lines of the mordant gilding (where the gold leaf is cap-
tured by a sticky medium) have the dynamic quality of a diagrammatic
shorthand – speed-writing, in fact. And the way the light is painted on the
sharp folds of Gabriel's garments creates a similar effect. The artist's dis-
tinctive and spontaneous touch is also apparent in the foliate frieze of the
architecture and in the tiny dove and the lilies in the vase.

　　This panel was originally part of a huge altarpiece that has been dis-
membered. If it had remained intact it would be harder to concentrate on
the narrative power or the beauty of this or any other single panel of the
ensemble. Not all of the other panels were of equal quality, or indeed by
Duccio himself, as is evident if we study the other two which are in the
National Gallery (NG1140 and NG1330), in one of which the architectural
background has no relationship to the figures and in neither of which the
figures have any of the same grace in their movements.

## TITIAN
### Pieve di Cadore *c.*1485–1576 Venice

### *Noli me Tangere*, *c.*1514

Oil on canvas, 110.5 x 91.9 cm
Bequeathed by Samuel Rogers, 1856
NG270

TITIAN PAINTS MARY MAGDALENE at the moment she has recognised the risen Christ in the garden and he enjoins her not to touch him: 'Noli me tangere.' The artist had begun his career about a decade before as a painter of landscape as well as of figures. Here the landscape complements, balances and repeats the actions of the figures and draws attention to the tense, poignant exchange of looks. The line of Christ's back and the inclination of his head are continued in the hillside to the right, while the tree behind him, together with his right arm and leg, provide a contrast with this movement. The tree, however, also continues the line of the Magdalen's back and connects her eyes with those of her Saviour, just as the window moulding links the eyes of the Virgin Mary and the Angel Gabriel in Duccio's panel of two centuries earlier (see pages 12/13). The bush behind Mary Magdalene imitates her kneeling form and echoes, in its flurried brushstrokes, her tremulous excitement. This dramatic interplay between trees and figures was to be a feature of Titian's *Death of St Peter Martyr* – long regarded as his greatest altarpiece but destroyed by fire in the nineteenth century – and of the celebrated paintings of Ovidian subjects that he made for the king of Spain, notably *Diana and Actaeon* (NG6611).

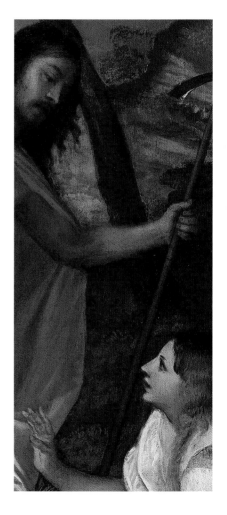

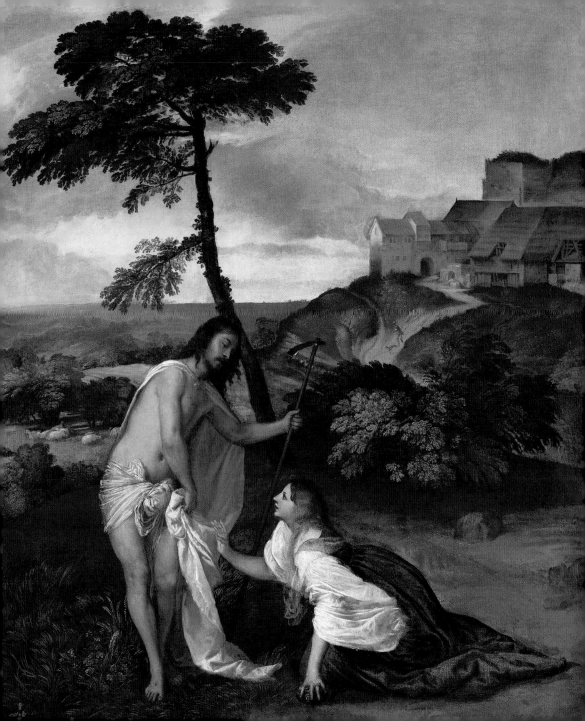

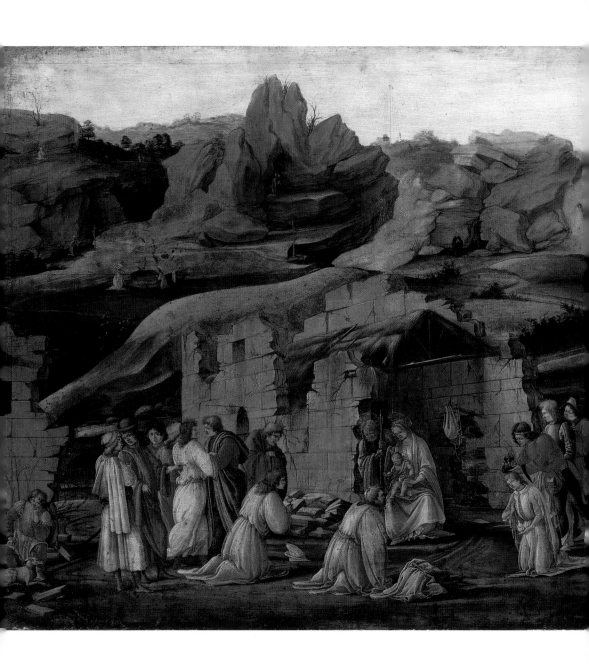

FILIPPINO LIPPI
Prato *c.*1457–1504 Florence

### *The Adoration of the Kings*, *c.*1480

Oil with some egg tempera on wood, 57.5 x 85.7 cm
Purchase, 1882
NG1124

THE SEEMINGLY FANTASTIC landscape that Filippino Lippi has devised as a setting for *The Adoration of the Kings* is based on a close study of limestone formations, the eroded stratifications of which have a linear character that is found here also in the way that folds of fine fabric fall over kneeling feet and pool on the ground. Filippino had studied perspective, and the receding lines of the ruins which serve as a stable, and the way that the horse is depicted rump-first, help to define a geometric space, but our attention is seduced by the lines winding through the rocks, into the background, along the routes we imagine that the kings have followed. Here we find that the rocky landscape is punctuated by a variety of religious episodes which are not easily identified without a magnifying glass.

The chief subject matter is clear enough but it is treated in a surprisingly capricious way. The kings are distinguished by their kneeling posture, but not by their apparel, and their gifts are also inconspicuous; moreover, several of the retinue have a prominence which cannot be explained by the narrative – notably, the seated youth to the left, with his hound on vermilion traces; the youth in profile on the right, elegant, distinguished, idle, and hardly engaged by the great event taking place a few feet away; and the one dressed in rose on the right, who even looks away.

CARLO CRIVELLI
Venice *c.*1430–*c.*1494 Ascoli

*Nativity* (from the predella of ***La Madonna della Rondine***), after 1490

Egg and oil on poplar, 150.5 x 107.3 cm

Purchase, 1862

NG724.2 (part)

NO DRAWINGS BY CRIVELLI seem to have survived, but this panel – still part of the predella (the plinth of the frame of an altarpiece) for which it was made, and thus easy to neglect – gives the impression of one. Its appeal derives primarily from lines, highly descriptive lines that emphasise the hardness of the world – blocks of masonry, the salient backbone and ribs of the ox, the rough-hewn corner post of the stable. Christ lies on the stiff folds of his mother's cloak, where the diagonal of the lines established by the architecture is intersected by the diagonal of the ass and the path behind it. This is a perfect demonstration of how a scheme of linear perspective, introduced as a way of defining pictorial space, can be adapted to serve as a compositional device. The sky is white but is embossed with gold stars, leaving little doubt that it was originally glazed with dark grey. So the painting was among the first nocturnes in European painting. The distinct shadows of the utensils in the stable are cast by the light miraculously emanating from Christ. A neighbouring panel in the predella features one of the most notable sunrises in the National Gallery.

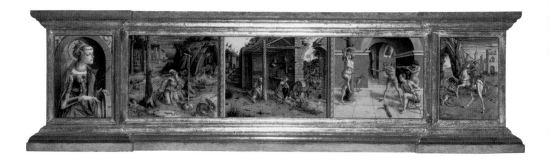

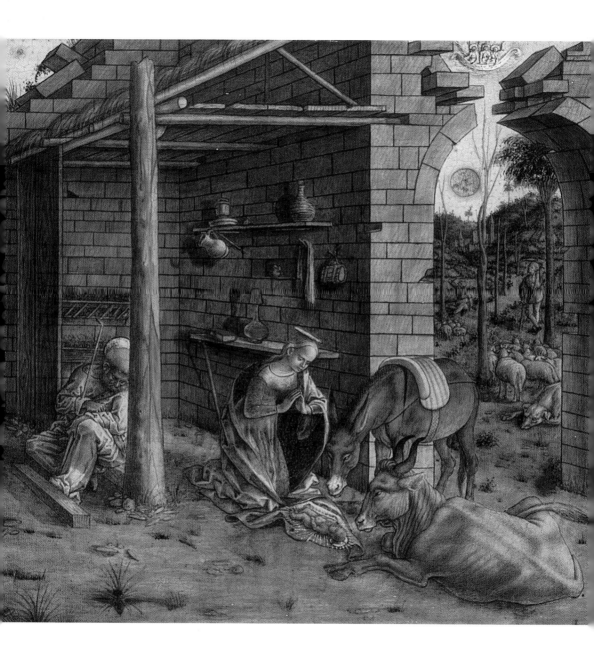

ROBERT CAMPIN
Tournai? *c.*1378–1444 Tournai?

*A Man* and *A Woman, c.*1435
Oil with egg tempera on oak, 40.7 x 28.1 cm / 40.6 x 28.1 cm
Purchase, 1860
NG653.1 and NG653.2

THESE ARE AMONG the earliest portraits in the National Gallery. No likeness in the
Collection has greater impact than this woman's glowing face, with her swelling
cheeks and shining eyes set off by layers of crisp white linen pinned into place
around it – the impact being formal yet personal, the slight blush suggesting mod-
esty as well as vitality, the gaze both distant and alert. The wrinkled fingers below
contribute little to the image except for the eye-catching light on the gold ring
and its ruby. The contrast with her husband must be calculated but the artist has
done little to make these portraits complementary in composition. Not even the
light source is the same, as would be expected in companion portraits made at a
later date, but since the reverse of both panels is decorated, it may be wrong to
suppose that they were ever intended to hang together on a wall.

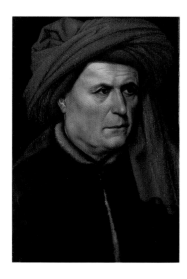
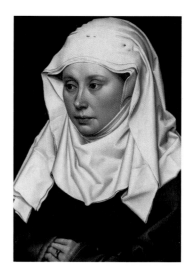

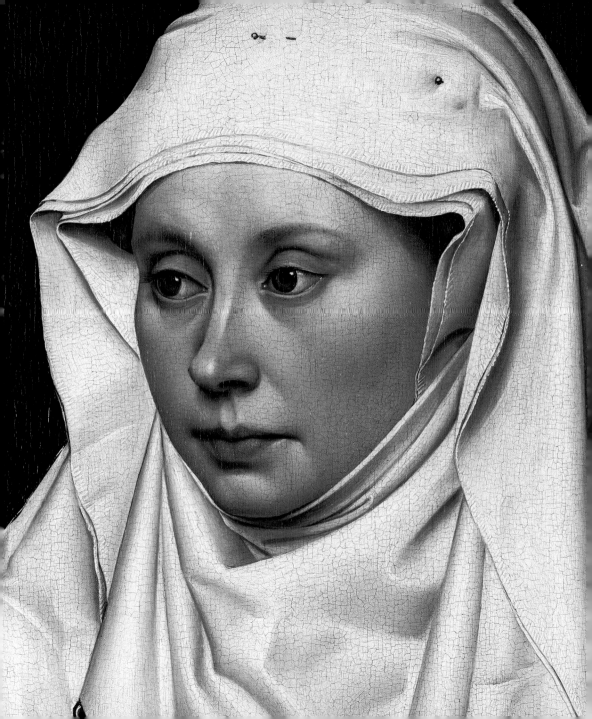

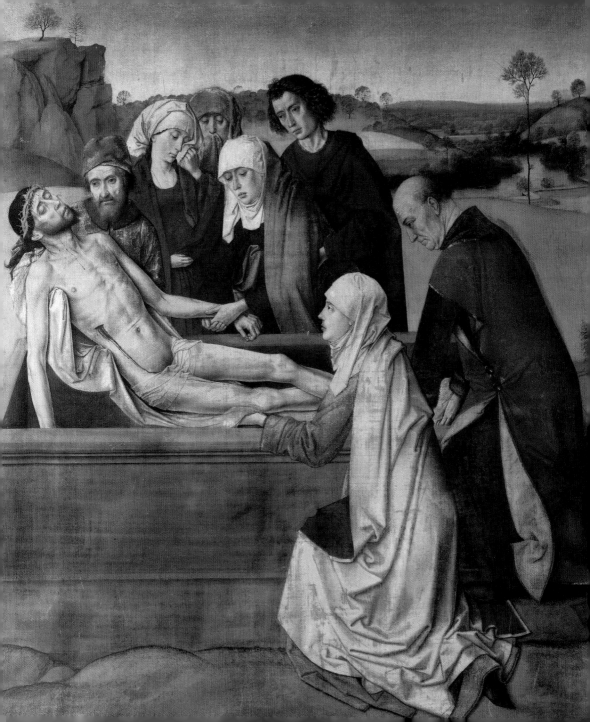

DIRK BOUTS
Haarlem 1400?–1475 Haarlem

*The Entombment*, probably 1450s

Glue tempera on linen, 87.5 x 73.6 cm

Purchase, 1860

NG664

THE SUBDUED COLOURS of this painting – a consequence of the medium employed and of more than 500 years' wear – seem well suited to the hushed grief and reverent care with which Christ's body is lowered into the tomb. The landscape now appears somewhat mistier than was originally intended, but in the distance, beyond the segmental curves of the hills and the tall, delicate tree-trunks, it possesses a character that would have been familiar to northern Europeans, and the painting perhaps includes contemporaries of the artist. If the subject is really the Entombment itself, as the National Gallery's title suggests, or, rather, if it is merely this, we have a right to be puzzled by the compositional priorities. Six figures are packed into a rectangle behind the left side of the tomb chest. This group includes the Virgin Mary, who alone makes direct physical contact with Christ's body. Having held his hand to her lips, she loosens his wrist. The Virgin and Saint John, who supports her, are less prominent than – we may even say they are upstaged by – the two figures to the right, who are nearer to us. These figures must represent one of the Marys and either Joseph of Arimathea or Nicodemus, but surely they are also portraits of the couple who commissioned this painting and the large altarpiece of which it was a part. Typically of such portraits, the couple are depicted kneeling and in profile. So, for me at least (although it is impossible to prove), the subject of this painting is the devotion of a fifteenth-century couple before the Entombment of Christ. That they are actually taking part in the Entombment as well as witnessing it is remarkable, although not without parallels at that date. This reminds us of the powerful effect that art could have in religious life, for the illusion that one might participate was what devotional narrative paintings strove to achieve.

ANTONELLO DA MESSINA
Messina *c.*1430–1479 Messina

**Christ Crucified**, 1475

Oil on wood, 41.9 x 25.4 cm
Purchase, 1884
NG1166

AN ART-LOVER IN 1475 – the date on the dog-eared piece of paper painted as if stuck on the edge of this picture – would have marvelled (more than is possible for us today) at the illusion that this really was a piece of paper. And no doubt the depiction of landscape too would have seemed far more marvellous, since it had seldom been seen before. Antonello da Messina's inspiration came from Netherlandish paintings but he was no mere imitator, and reconciled the minute naturalism of an artist like Bouts (see pages 22/23) with a pictorial geometry that unites foreground and distance – for instance, the way the hills rise to either side, rhyming with Christ's arms. The tall Cross divides the composition vertically but the landscape is also divided horizontally by the distant band of sea and by a separate, nearer strip of water. This water carries into the lower part of the picture the blue of the higher reaches of the sky, and prepares us for the deep blue of the Virgin's cloak and the greyer blue of Saint John the Evangelist's tunic, the former falling into a cascade of crystalline folds. While relishing effects of aerial perspective, Antonello delights in a play between spatial illusion and surface pattern; and the lucidity of this exercise, combined with the beauty of the light, is also found in Piero della Francesca's larger and far more famous *Baptism* displayed a few rooms away (NG665).

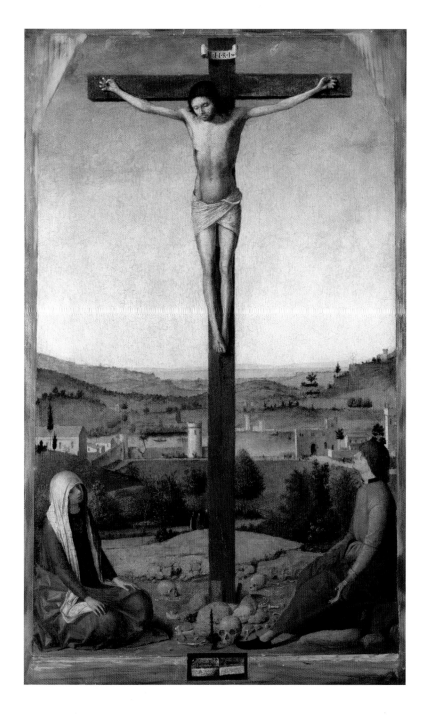

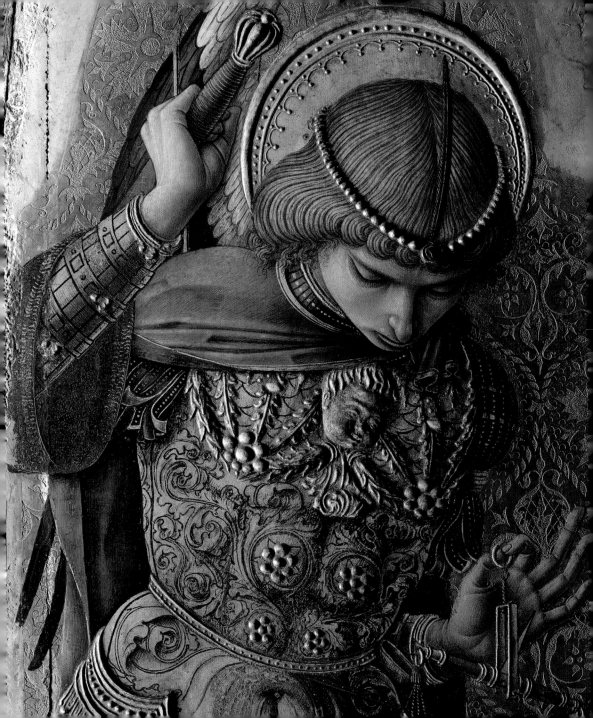

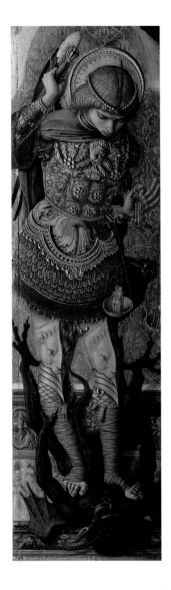

CARLO CRIVELLI
Venice *c*.1430–*c*.1494 Ascoli

### Saint Michael, *c*.1476

Tempera on poplar, 90.5 x 26.5 cm
Purchase, 1868
NG788.11

CRIVELLI'S PANEL is one of four spectacular fifteenth-century paintings of the Archangel Saint Michael in the National Gallery (others are by Perugino, Piero della Francesca and Bermejo). Saint Michael is clad in the armour in which he fought against Satan and the rebel angels, and holds the scales in which he weighs the souls of the dead. The panel was originally part of a polyptych (an altarpiece composed of separate units). Three of the other panels are also in the Collection, and the central *Virgin and Child* is in Budapest. The wood panel is poplar, coated with gesso (a hard white plaster), built up in relief for some of the gilded parts, which would have caught the candlelight from below. This was not an uncommon device for haloes, but here it is also used for the buckles on the leg and arm armour, the pommel of the sword handle, the cherub embossed on the breastplate and the rims of the bowls of the scales. There is also a glass-paste jewel in the helmet, from which a single painted feather springs. This witty incorporation of genuine relief is combined with much foreshortening, as in the saint's lowered head or the raised one of the devil beneath his feet. Such foreshortening is an aspect of the Renaissance rediscovery of perspective, but the pictorial space made possible by that rediscovery is here severely limited by the background: a flat, decorative brocade pattern executed in the sharpest lines and the finest punching of burnished gold leaf. The exceedingly rich effect created by this complex combination of gold armour, both executed in shallow relief and painted in imitation of relief, and placed against an engraved gold ground, also the tightness of the patterns and the compression of form, leave us nearly confused – more so than is normally compatible with aesthetic satisfaction.

MICHELANGELO
Caprese, near Florence 1475–1564 Rome

### The Virgin and Child with Saint John and Angels ('The Manchester Madonna'), c.1497

Tempera on wood, 104.5 x 77 cm

Purchase, 1870

NG809

So NAMED BECAUSE of the stir it caused at the huge loan exhibition that took place in Manchester in 1856, '*The Manchester Madonna*' would not have been included in that exhibition had the trustees of the National Gallery agreed to acquire it ten years earlier, as Charles Eastlake, then the keeper, proposed they should. The trustees probably felt that an unfinished picture would be of little interest except to historians of art and art students, and Eastlake had perhaps been too cautious to advance the idea, already gaining support among some connoisseurs, that this was a painting by the young Michelangelo. Eastlake was deeply disturbed by this incident, and it led to his resignation. When he became director he witnessed the fame and value of the painting increase. It was eventually bought for the National Gallery by his successor, William Boxall.

The group of the Virgin and Child has a compact character such as might be extracted from a block of marble, and the miniature cliffs that serve as a plinth for the Virgin's stone seat closely resemble the type of base that Michelangelo created for his statues: the parallel lines of the brushstrokes even suggest the traces of a claw chisel. Each of the pairs of boy angels is also blocky in character and, in addition, they seem to form a wall behind the Virgin and Child. The angels on the left are reading the prophetic book held by the Virgin, while those on the right study the scroll brought by the infant Saint John the Baptist. Christ himself turns from his mother's breast to help interpret the book. Thus the painting is a meditation on Christ's future sacrifice. Although some sort of symbolic reference to the Passion was commonplace in Florentine paintings of the Virgin and Child with the infant Saint John, they seldom possess a solemnity of mood such as we find here. Book and scroll are also common in such paintings but they are never given such a prominence and studied equivalence as they are in this case. Michelangelo has dispensed with the setting and many of the accessories that are familiar in paintings of this

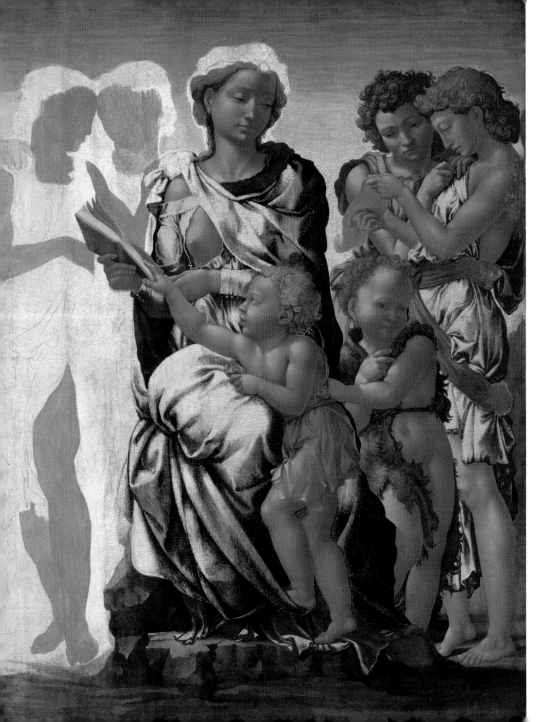

subject: the flowers, carpets, opulent throne and ornamental dress, also the distant hills and spires. He was, however, planning to employ precious ultramarine blue for the Virgin's robe, and doubtless some gold, including perhaps a fine gold cross in the raised hand of the Baptist, who seems at present to stare at nothing. Such a cross might also be the focus of the Virgin's gaze.

The angels are also unusual. Instead of simply sticking wings on to drapery, Michelangelo has tried to imagine how feathers might plausibly grow out of a human body. The treatment of the hair is sculptural, inspired by the sort of arrangements that can be found in some antique heads and in the works of Donatello, and echoing Michelangelo's marble sculpture of Cupid (see below), rediscovered nearly 15 years ago in the French Cultural Institute in New York by Kathleen Weil-Garris Brandt (and now on loan to the Metropolitan Museum).

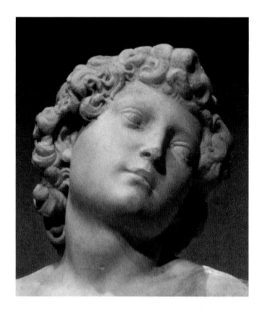 

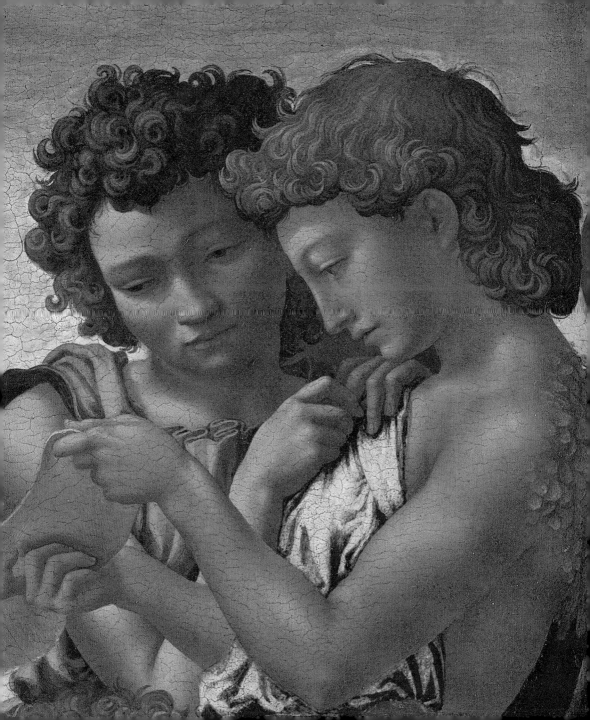

ANDREA MANTEGNA
Isola di Cartura, near Padua *c.*1430–1506 Mantua

## *A Woman Drinking*, *c.*1495–1506

Tempera on poplar, 71.2 x 19.8 cm

Purchase, 1882

NG1125.2

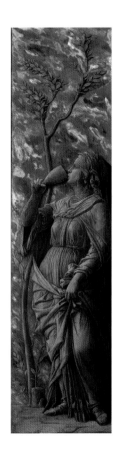

CRIVELLI's *Saint Michael* (see pages 26/27) is a painting that incorporates some elements of sculpture in low relief. Michelangelo's '*Manchester Madonna*' (see pages 28/29) is a painting, by a sculptor, of figures which he may have hoped to carve in marble. This painting by Mantegna of an ancient heroine represents a relief sculpture of gilded metal, or perhaps merely bronze with a yellow patina. We are to suppose that it has been applied, as some reliefs then were, to a coloured stone slab – in this case an alabaster that evokes the smoke of a funeral pyre or a destroyed city. In some lights the painting might be mistaken for relief sculpture, even if only for a moment. Previously, such fictive sculptures had usually imitated carvings in ivory, alabaster and marble. They were favoured especially for the backs of shutters (fine examples may be glimpsed on the reverse of the side panels of the *Donne Triptych* by Hans Memling, NG6275.1), and imitations of coloured stone had also been painted on the back of small pictures on panel. It may be that Mantegna's figure originally adorned the panel of a cupboard door or window shutters in a luxurious little room in Mantua, where he was the court artist. The markings on the cup held by the heroine (who may be Sophonisba swallowing poison to avoid being taken prisoner or Artemisia drinking wine mixed with her husband's ashes) show that it is of banded calcite alabaster, a stone from Egypt known to have been favoured by the ancient Romans. Mantegna collected and studied such stones, as well as ancient sculpture in both bronze and marble which certainly inspired the representation of light fabric revealing the forms of the body beneath. And yet he can never have seen sculptures which matched virtuoso passages such as the deep hollow of the sleeve or the complex crumpled fabric below the heroine's left hand. Thus Mantegna, an artist who designed and perhaps modelled for sculptors and goldsmiths, makes a painting of something that was beyond their ability to create.

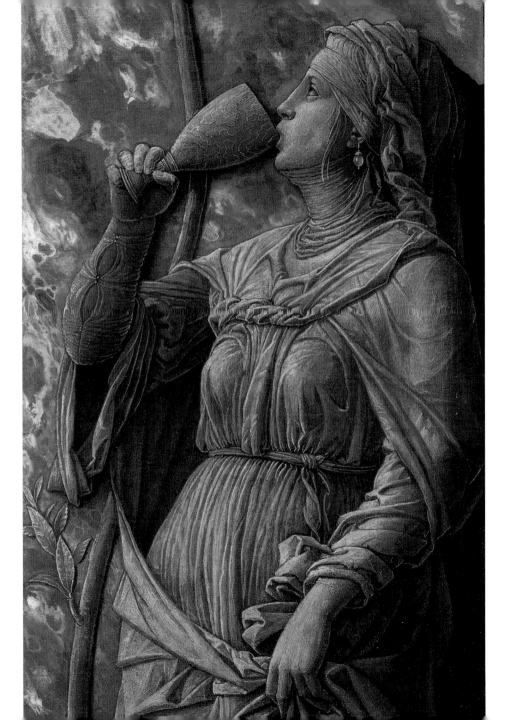

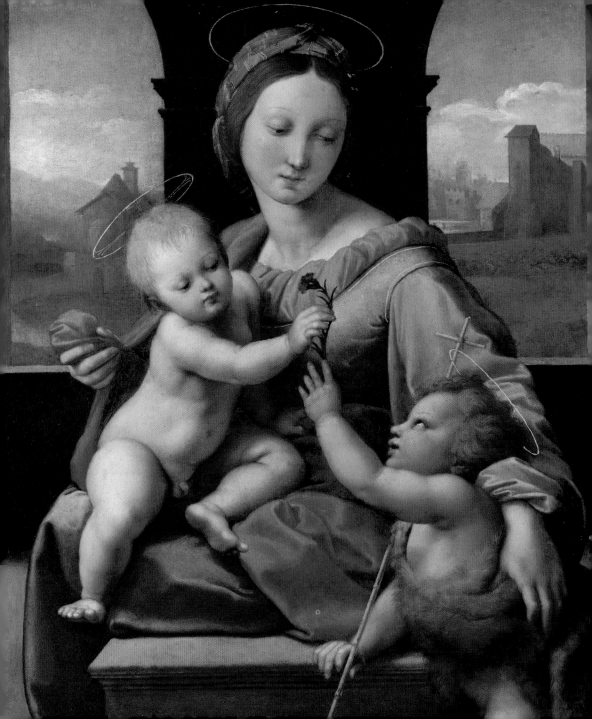

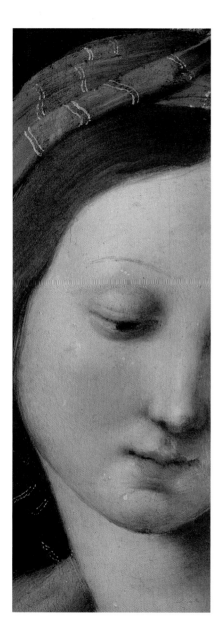

RAPHAEL
Urbino 1483–1520 Rome

**The Madonna and Child with the Infant Baptist**
(**'The Garvagh Madonna'**), *c.*1509–10
Oil on wood, 38.9 x 32.9 cm
Purchase, 1865
NG744

IDEAL BEAUTY could be defined as the elimination of distracting individuality, which makes it sound rather bland; or as the admixture of some inexplicable grace, which sounds mystical; or as the adjustment of natural forms by an emphasis on abstract ones, which sounds pseudo-scientific. My preference, in the case of Raphael, is with the last of these explanations. A study of his drawings reveals that he was instinctively attracted to two- and three-dimensional geometry. This guided him as he studied the living model and informed the composition of his paintings. Thus, here, the oval of the Virgin's head, the curve of her hair and her eyebrows, the line of her shoulders and of the arches behind, are all related and seem to grow out of each other, at the expense of any idea of probable architectural space or anatomical construction, for it is unwise to guess where the Virgin sits or how. The painting is the last in a remarkable series of small panels of this subject, a series which includes the *Madonna of the Pinks* (NG6596), and was made at a moment when Raphael was beginning to give the sensuous world a larger part in his art, emphasising in his architectural settings the textures and colours of stone, and in his figures, the sheen and softness of flesh, fabric and fur. Hints of this may be found in the Virgin's exquisite headscarf of striped silk into which gold thread is woven, and in the deep fur of the Baptist's cloak, into which the Virgin's fingers disappear.

CORREGGIO
Correggio 1489?–1534 Correggio

### *The Madonna of the Basket*, c.1524

Oil on wood, 33.7 x 25.1 cm

Purchase, 1825

NG23

THIS PAINTING HAS AS ITS SUBJECT a daily domestic task: that of inserting an infant into his or her clothes and, in particular, arms into a jacket. This is often a test of parental patience but here it is achieved with exuberant ease by the young Christ, much to the delight of his mother. The garment in question is a jacket of a lovely lilac grey, newly made by the Virgin Mary out of the wool in the basket before her, after which the painting is named. A prefiguration of the Crucifixion may have been intended by this outstretching of Christ's arms but here there is none of the solemn atmosphere of the '*Manchester Madonna*' (see pages 28/29): the Virgin seems to tickle Christ's left palm as he merrily kicks out his right foot. The wool basket, front left, is matched by the vignette of Joseph driving a wood plane, back right, an emphasis on the Virgin and Saint Joseph as a working couple which is fairly rare in Italian art. Correggio learnt much from Raphael, but the continuously flowing – one might even say wriggling – lines, moving backwards and forwards in space and involving the bank on the right and the bark of the trees upper left, also the instability of Christ's pose, the way fingers spread and facial features grow, contrasts with the stable geometry of the '*Garvagh Madonna*' (see pages 34/35).

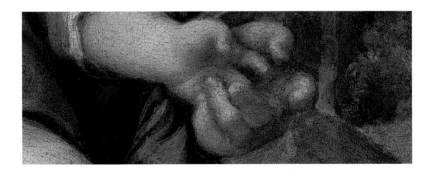

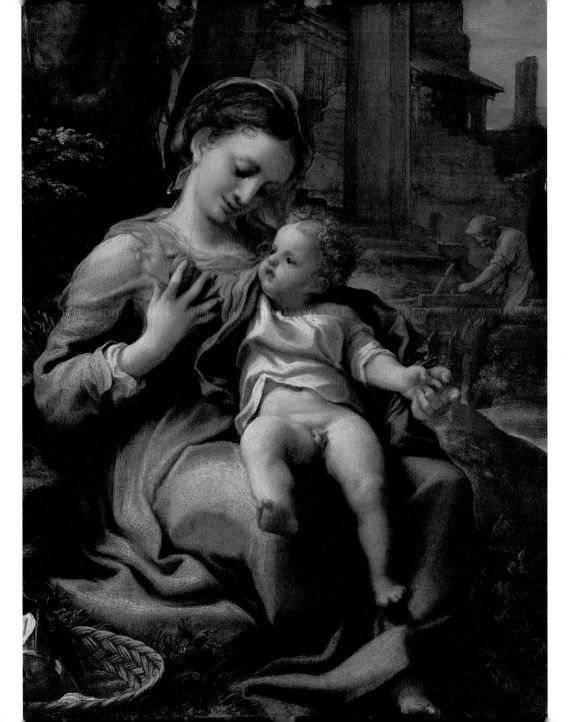

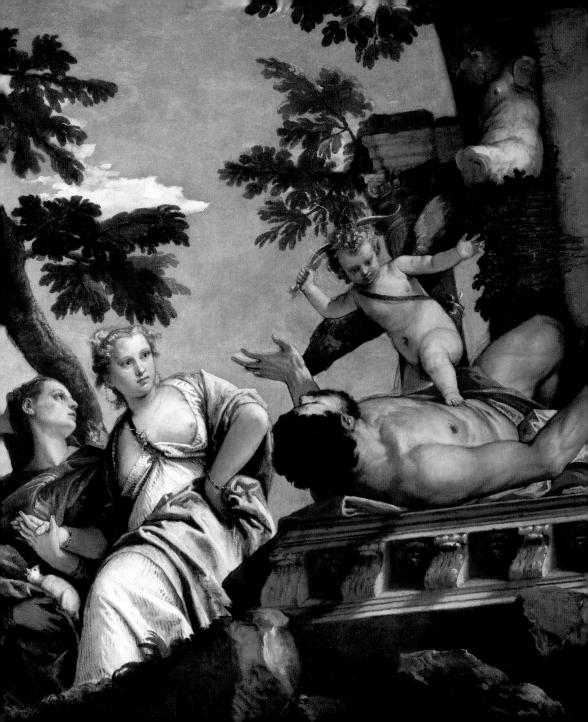

PAOLO VERONESE
Verona 1528–1588 Venice

**Scorn** from **Four Allegories of Love**, *c.*1575

Oil on canvas, 186.6 x 188.5 cm

Purchase, 1891

NG1324

THIS IS ONE OF A GROUP of four allegorical ceiling paintings that Veronese made perhaps for a foreign patron. They may have been designed for a set of rooms, or for two sets, probably the apartments of a newly married couple, with a theme appropriate to marriage (the chief pretext for new decorative schemes). Hung on a wall, as they are now, the paintings look odd because the architectural verticals are tilted. Each of the compositions is constructed around diagonals. In the case of this painting the composition is especially bold and ingenious: the diagonals meet in, and are epitomised by, the lively central figure of Cupid, who is thrashing the supine man with his bow. The title *Scorn* was given to the picture in the early eighteenth century but it is not inappropriate for the demeanour of the women on the left. One of them carries an ermine, an emblem of chastity. Whether the man is tormented by desire or rebuked by love, he clearly needs to be civilised. The fragmentary stone satyr to the right serves as a reminder of the lustful animal within.

The painting, economical in handling as well as bold in composition, is calculated to be seen from a distance. The sky was originally blue, and some of the pink and green in the silk cloak of the principal woman has faded. These richer colours would have contrasted with her clear complexion, enhancing a beauty which has been made more captivating by a faint blush of indignation, and by the slight disorder of her blonde hair.

PETER PAUL RUBENS
Siegen, Westphalia 1577–1640 Antwerp

### *The Apotheosis of the Duke of Buckingham*, before 1625

Oil on oak, 64 x 63.7 cm

Purchase, 1843

NG187

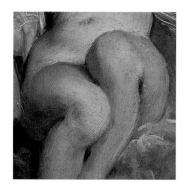

GEORGE VILLIERS, DUKE OF BUCKINGHAM, favourite of James I and
Charles I, is here elevated to the celestial sphere: raised up by
Minerva, representing Order and Wisdom, and Mercury, repre-
senting Diplomacy and Eloquence; and crowned by the Graces,
despite the attempts of Envy and Anarchy to pull him down. This
is a sketch for a ceiling painting in York House and is entirely by
the artist's hand, as the larger finished work would not have been.
Moreover, at the scale of this sketch the machinery of courtly alle-
gory seems less laborious, and the incongruity of a figure in
contemporary armour consorting mid-air with the gods of ancient
Greece and Rome is less obtrusive. The entire composition is in
motion, from the lion's tail to the spiral fluting of the twisting col-
umn (a rare type of antique column associated with the Temple of
Solomon), while all the spaces between the figures are filled with
either turbulent clouds (sometimes concealing previous ideas for
figures) or windblown drapery, and shot through with rays of
light. The figures form chains, most literally so in the case of the
duke, but every group has an organic unity that connects dynam-
ically with another. Foreshortening enables figures to be given
novel forms of dynamism, as in Mercury's case, by the apparent
continuation of his right forearm in his left leg, and it also enables
them to be combined in unexpected rhythms. Thus the bodies of
the Graces on the left are interwoven in a manner that recalls
Raphael's designs for the vault of the Farnesina, but here with an
enhanced emphasis on soft rotundities – not only of breasts and
buttocks but, most memorably, of projecting knees.

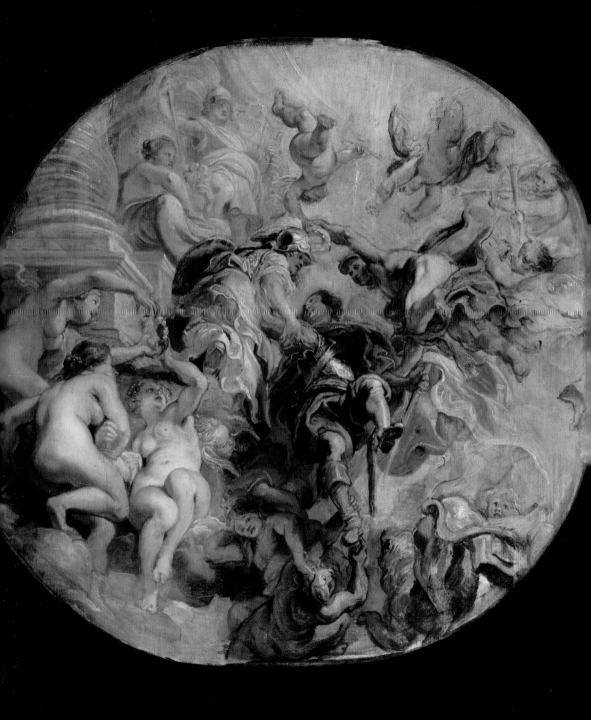

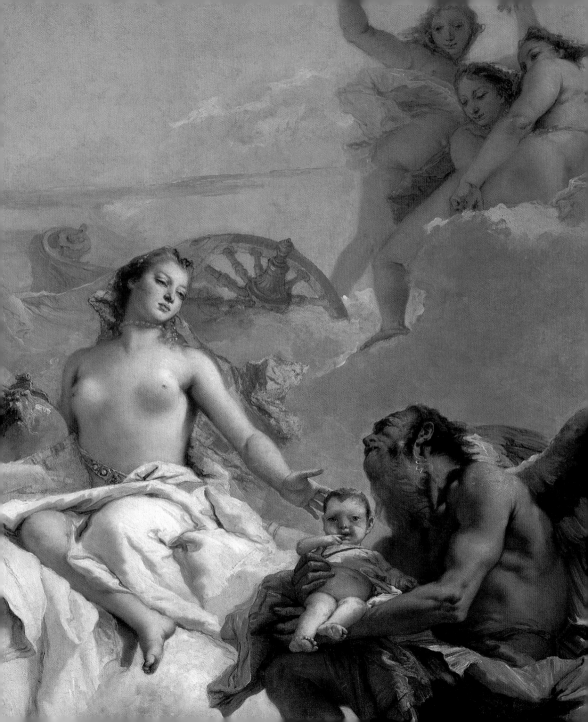

## Giovanni Battista Tiepolo
Venice 1696–1770 Madrid

### *An Allegory with Venus and Time*, *c.*1754–58

Oil on canvas, 292 x 190.4 cm

Purchased with a special grant and a contribution from The Pilgrim Trust, 1969

NG6387

THE SUBJECT MAY SIMPLY BE Venus, the goddess of love, consigning to Father Time a baby, presumably a boy, upon whom the Three Graces shower their gifts: an elegant and poetic visualisation of the topic proper for a wedding toast – the hope for a loving and fruitful union. In all probability it was painted for the ceiling of the bedchamber of a newly-wed Venetian patrician, and set originally within white plasterwork banded with pale lilac and yellow, touched with gold. The shape of the painting follows the cusped curves of this decorative scheme. Horizontals are reduced to faint bars of cloud, upper left, and the pole of the goddess's chariot in the centre on the right; and the only notable vertical is the straight back of the queenly goddess. She is surrounded by draperies of white, pink and yellow, perhaps the single most exhilarating combination of colours in the National Gallery, chosen also because they are combined in her pale flesh. Elsewhere, the Graces are close in colour to the clouds that support them, enhancing the illusion of their liberation from gravity.

Space is constructed by means of a zigzag (in this case a reversed and tilted 'Z'), a popular compositional device in eighteenth-century Venice which can also be found in Pittoni's altarpiece in the same room. The zigzag is established by the staff of Time's scythe, taken up by the outstretched arm of Venus, continued by the less distinct and more distant diagonals of the limbs of the Graces, and concludes in the fluttering brace of amorous doves.

JOHANN LISS
Oldenburg, Holstein *c.*1595–1631 Verona

### *Judith in the Tent of Holofernes*, *c.*1622

Oil on canvas, 128.5 x 99 cm
Presented by James W. Dollar, 1931
NG4597

JUDITH, AFTER SEDUCING THE ENEMY commander Holofernes, has beheaded him. The event is depicted as a close-up, which is confusing as well as dramatic. The torso falls towards us, blood spurting from the neck, as the heroine turns to rush out of his tent with the head, but the action seems frozen into a richly complicated knot. It is a shock to find the dead eye of Holofernes – rhymed with the living one of the terrified slave who opens the bag into which it is dropped. And just as violent action turns into elegant, twisting movement, so too does everything resolve into creamy paint. Spurting blood achieves a weird decorative effect, while paint of a similar colour ripples through the heroine's turban and serves as a decorative pattern in the golden textile, lower right.

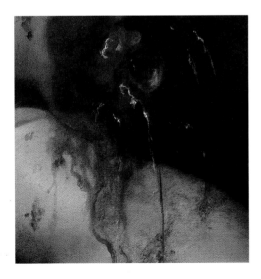 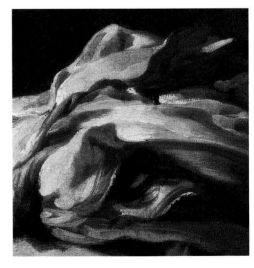

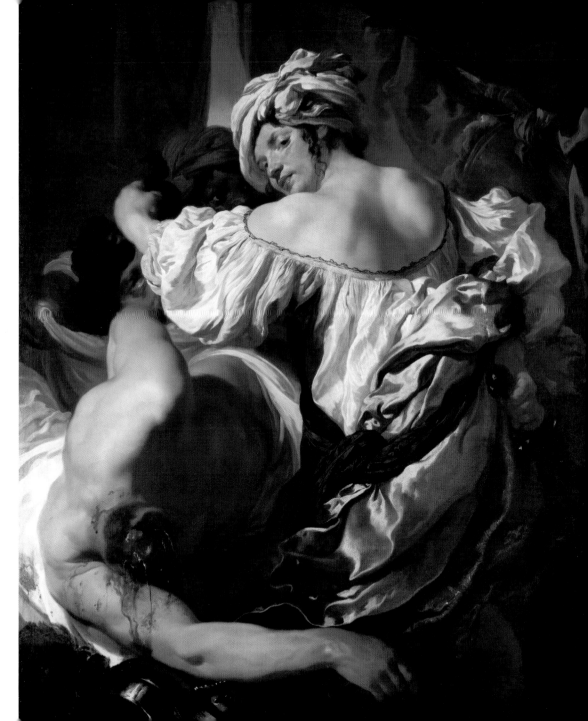

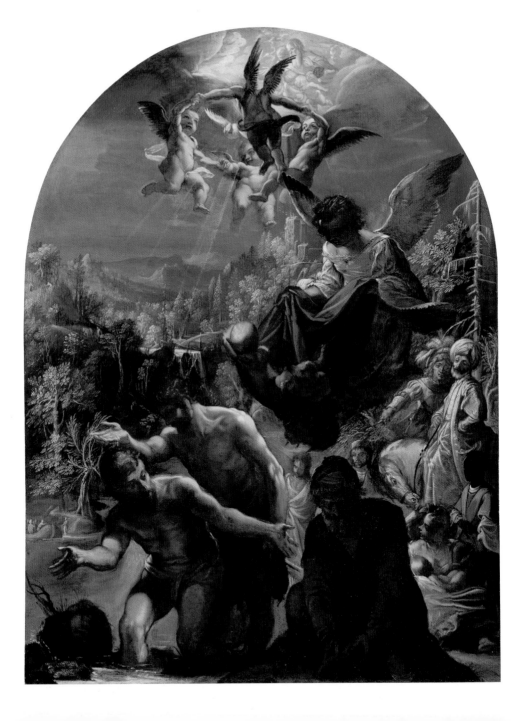

ADAM ELSHEIMER
Frankfurt 1578–1610 Rome

*The Baptism of Christ*, *c.*1599

Oil on copper, 28.1 x 21 cm
Presented by Henry Wagner, 1924
NG3904

THIS SMALL PAINTING on copper represents a synthesis of German and Italian art, in which inventions that can be traced back to Dürer, whose prints Elsheimer must have known since childhood, are combined with devices that are indebted to Tintoretto, with whose works Elsheimer became acquainted during his stay in Venice. The ring of snub-nosed angels in the sky is tilted so that we can just glimpse God the Father, distant and spectral, his right hand visible between the uppermost wings. The dove and beams of light emanate from him, the latter touching Saint John the Baptist as he trickles water on to Christ in the river Jordan below. Christ gestures to the others who are preparing to be baptised, notably the man in the foreground, prominent but in shadow, who is removing his shoe – a detail taken from Tintoretto. Usually, in representations of this subject, angels stand by on the river bank with Christ's robes, but here they fly above. In the background, seen through the larger forms, we find a cascade in a spectacular Alpine forest, its distant splashing wittily related to the water falling from the Baptist's palm. Among numerous details worth examining minutely is the piebald horse ridden by one of the Pharisees witnessing the scene, whose distended muzzle suggests that it is being tormented by a fly.

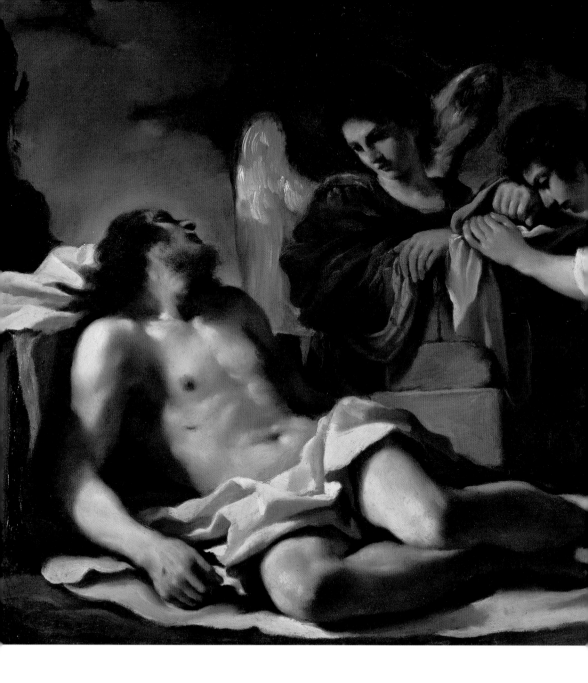

GUERCINO
Cento 1591–1666 Bologna

### *The Dead Christ mourned by Two Angels*, *c.*1617–18

Oil on copper, 36.8 x 44.4 cm

Holwell Carr Bequest, 1831

NG22

THIS PAINTING IS ON COPPER, a support, usually small, that was often favoured by artists such as Elsheimer who worked in fine detail. But this picture has a real monumentality and reminds us that the artist would be equally happy painting on a much larger scale (large works by him can be seen in the adjacent gallery). This is not a painting in which we discover more when we look closely into it. Rather, we see less and thus lose ourselves, or part of ourselves, in contemplation of the subject, and also in the colours, which have a depth suggestive of precious stones, and a softness associated with deep-piled velvet. The painting gains by the proximity of another masterpiece of the Bolognese School, the *Three Maries* by Annibale Carracci, a work in which every separate part is clearly defined. Guercino's forms have no firm edges: Christ's body is continued in the outline of the clouds behind and in the pool of drapery before it, and even the profile of his face is 'lost'. The seduction of the eye in which Guercino engages here, also the removal of secure compositional structure, owes much to his study of Correggio (see pages 56/57).

UNKNOWN NEAPOLITAN ARTIST

*The Adoration of the Shepherds*, probably 1630s

Oil on canvas, 228 x 164.5 cm

Purchase, 1853

NG232

RELIGIOUS PAINTINGS were sometimes given new vitality in the seventeenth century by the incorporation of common people – born, like Christ, in poverty, and working, like Joseph, with their hands. The two kneeling shepherds and the child gripping the basket and proffering a hen appear to be natives of New Spain – Andean people stunned into a new faith. The decorous homage of the comely poor (those in Guido Reni's huge altarpiece in the neighbouring room, for example) does not convey the same idea of sudden revelation which is in fact essential to the gospel account of the Adoration. The woman who leans over the shepherds is less exotic in appearance. Her wrinkled features and smile (the smile of the toothless) occupy the centre of the painting, and the rag that binds her jet black hair is the brightest white in the picture. Sweeping in from the columns on the left are the colossal forms of the ox and the ass, preparing to perform the function, described in medieval legends, of warming the infant Christ with their breath, although in fact he is very well wrapped. Above the distant hill a remarkable Icarus-like angel extends a long scroll of text for the benefit of the alarmed shepherds (although they were surely illiterate).

This is one of the most puzzling pictures in the National Gallery. When it was bought in 1853 from the Spanish Gallery formed by Louis-Philippe, recently deposed king of the French, it was considered to be an early work by Velázquez, but soon afterwards critics began to wonder whether it might not be by Zurbarán. For decades now, Spanish experts have considered it to be by a Neapolitan painter, and the Italians have been equally sure that it is Spanish. We need only compare the painting of the rolls and basket in the foreground with the eggs, fish and garlic – equally solid and inviting to the touch – in Velázquez's kitchen scene in *Christ in the House of Martha and Mary* (NG1375), which hangs nearby, to understand how it can have been thought to be by the same artist.

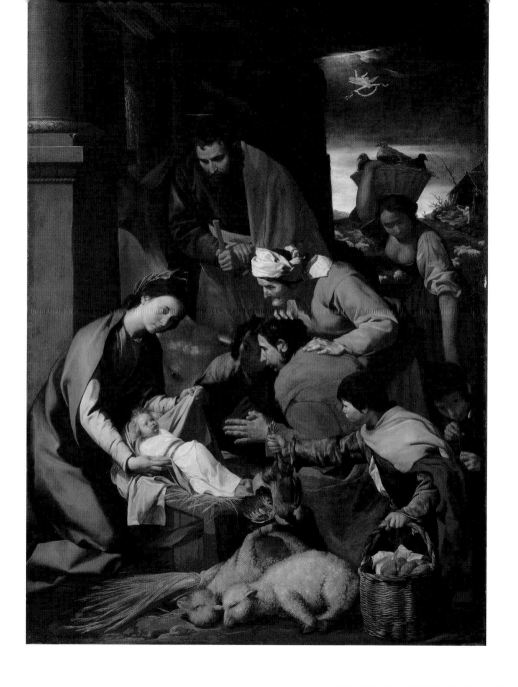

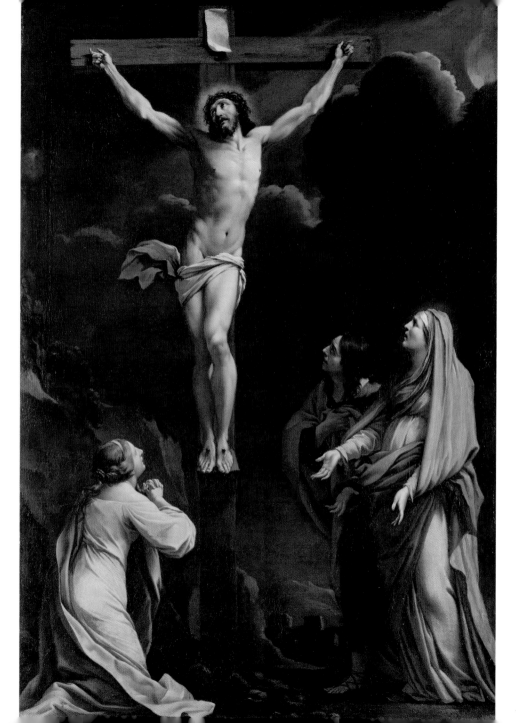

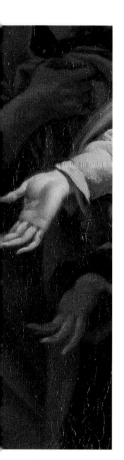

Eustache Le Sueur
Paris 1616–1655 Paris

## *Christ on the Cross with the Virgin and Saints*, *c.*1643

Oil on canvas, 109 x 73.1 cm

Purchase, 1994

NG6548

DEVOTIONAL PAINTINGS, however fine, needed to be, at least in some respects, familiar, even conventional. This is easily forgotten by art critics and historians, who tend to value the original and the unique. One part of this painting, the image of Christ on the Cross with his head turned upward and lips parted, would have been immediately recognised by Roman Catholics all over Europe not only for its subject – Christ uttering his last words – but for the elegance of its contours and its canonical proportions. The much admired and reproduced sculptures of this very subject fashioned in bronze, silver and ivory by Giambologna, Algardi and Duquesnoy are close in style, with a similar balance between physical beauty and pathos.

What is unconventional is the fact that the Cross is not in the centre of the painting. Its displacement is occasioned by the unusual disposition of the three figures who witness Christ's sacrifice. This must reflect the priorities of the patron, who was surely someone with a special veneration for Mary Magdalene, here shown separately on the left. Saint John and the Virgin Mary, on the right, are treated as a single unit. Two feet are visible: his left and her right. John's left hand mimics the Virgin's right hand and matches her left. Their profiles and expressions are similar (but her face is paler – as pale as that of Christ, her son).

The body of Christ, however sculptural, is not detached from the setting. The shadowed area of his chest seems continuous with the dark sky in which his loincloth floats like the clouds. Rocks crowned by a wind-torn tree rise steeply from a cluster of buildings resembling the tumbled boulders at the foot of the Cross. This hill is not at first distinguishable from the sky. The dark grey serves as a foil for Mary Magdalene's garments of yellow and rose – colours which are repeated in the moon (or it may be the dimmed sun) in the upper right corner. Such a correspondence between figures and a bare, elemental setting contributes greatly to the tragic mood.

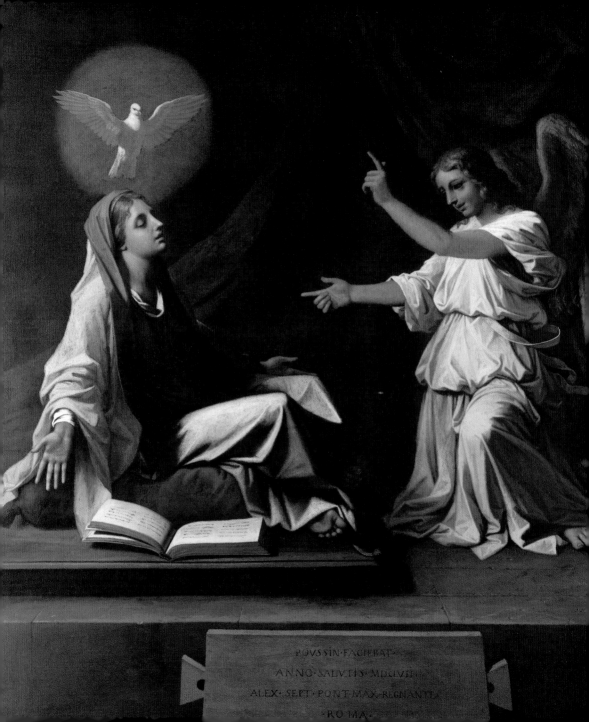

POVSSIN·FACIEBAT·
ANNO·SALVTIS·MDCLVII·
ALEX·SEPT·PONT·MAX·REGNANTE·
·ROMA·

NICOLAS POUSSIN
Les Andelys, Normandy 1594–1665 Rome

**The Annunciation**, 1657

Oil on canvas, 104.3 x 103.1 cm
Presented by Christopher Norris, 1944
NG5472

POUSSIN IS THE FIRST great European artist whose art, at least in its mature phase, was based upon renunciation – a conscious denial of liberties and pleasures – so that its character is most conveniently described by what it is not. His faces have no subtlety of expression but are frozen into masks. Gestures are bold and explicit, avoiding both elegance and naturalism. Drapery is cloth of a solid colour, falling into hard sculptural folds without the allure of texture or ornamental borders. Forms are clearly defined. Lines are edges and are not permitted to wind or coil with a life of their own. The effect of such a style when applied to mythical revelry such as we find in several paintings in the National Gallery is strange, yet it suits a view of biblical narrative in which the Virgin Mary is conceived of as someone who would sit cross-legged on the floor. Her eyes are closed and both her hands are open. The contrast with the way the Annunciation is represented elsewhere is extraordinary. Poussin is not concerned with realism: there is no attempt to evoke the Virgin's humble home, indeed no reference to any home at all, just a great sweep of drapery following the curve of the halo around the dove that hovers over her. A sort of purism is at work here, as in stage productions that make do with a bare set. In such a case it follows, of course, that lighting becomes all important, and here, in fact, light is the divine agent. It is not allowed to delight us by sparkling, or seduce us by softening. It has a higher mission.

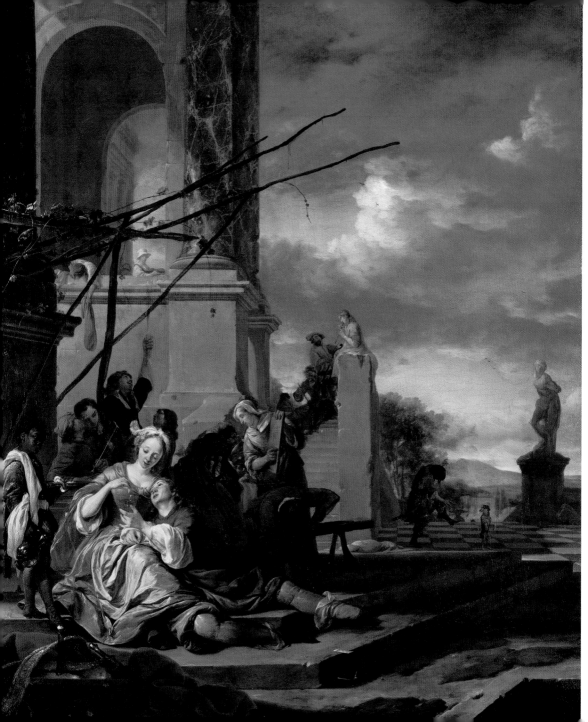

## Jan Weenix
### Amsterdam 1642–1719 Amsterdam

### *An Italian Courtyard*, probably 1660–65

Oil on canvas, 84.5 x 68.5 cm
Presented by Mrs Gifford-Scott, 1980
NG6462

THIS IS THE SORT OF complex, witty and luxurious comic the-
atre that we may feel in need of after the austere plainsong
and clear message of Poussin's *Annunciation*. The set is a
tavern in a Mediterranean port where the brief encounter
and rash fling may be expected; front left are the props of
elegant intemperance familiar from the still-life works that
Weenix often painted – ice bucket with glistening sword belt
tossed over it, silver ewer and platter, a long twist of lemon
peel, a tall glass, vine tendrils. This prepares us for the
couple, he oblivious to the potion she drops into his drink
as he gazes up adoringly at her, both of them deaf to the
drunken behaviour behind them and the mad music on the
balcony, music to which a clown ludicrously prances on the
terrace, clicking his fingers to encourage a dog on its hind
legs, a performance that is ignored by the writhing foun-
tain statue. This is only one of many contrasts within this
single frame between lyrical and grotesque, quiet and noisy,
bustle and peaceful vacancy, so perfectly co-ordinated that
a traveller's bundle is lowered as a glass is raised, so exquis-
itely co-ordinated in colour that the green of the trees and
the pink of the paving is prepared for by the page's livery
and the lady's silk dress, leaving us to wonder not only how
this scene will end but whether there is a companion pic-
ture, with a vanishing point to the left and perhaps a male
lover dominant in the foreground.

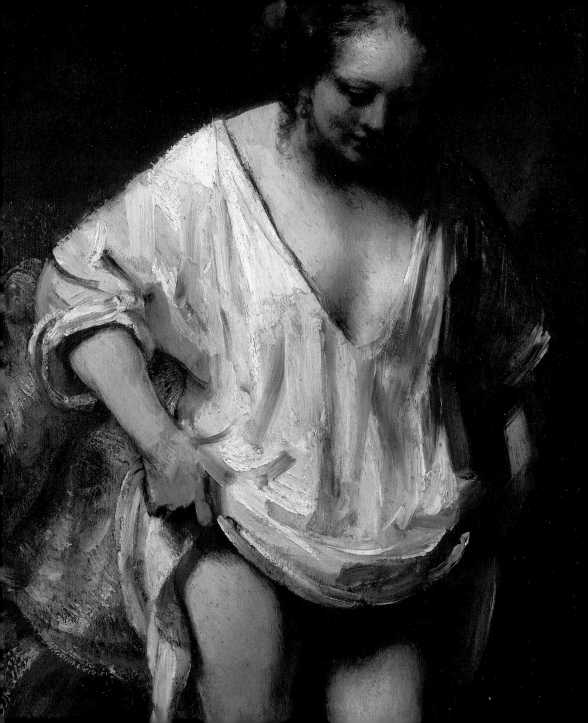

## REMBRANDT
### Leiden 1606–1669 Amsterdam

*A Woman Bathing in a Stream (Hendrickje Stoffels?)*, 1654

Oil on oak, 61.8 x 47 cm
Holwell Carr Bequest, 1831
NG54

THIS SMALL PAINTING on panel epitomises much that we associate with Rembrandt: a pensive mood; naked flesh set off by heavy, encrusted textiles and by a reflective surface, often armour or, as here, water; a figure glowing in the darkness of a cavernous space in which pillars and hangings are dimly perceived. This woman may be Bathsheba, already half aware of the effect she has had upon King David, but we know too that she is the artist's model and mistress. Rembrandt is the first great painter whose domestic life was inseparable from the character of his art, whether he was painting episodes from ancient history or, more rarely, mythology. This is indeed a painting of a model, a 'life study' such as later became a standard academic exercise but is rarely found in paintings of the fifteenth or sixteenth centuries. It was probably painted without reference to preliminary drawings because much that is marvellously realised is not understood – or at least understandable – as part of a coherent anatomical structure. The form of the woman's left hand is summary in treatment and her thumb is represented with a single brushstroke of the grey that is also used for the shadows of her smock.

The painting was bequeathed to the National Gallery by the Reverend Holwell Carr in 1831, one of a group of pictures, most of them relatively small and almost all by Italian artists, selected with great care to suit a London home. It seems often to have been regarded as a superb demonstration of the painter's power but a subject with limited interest. Yet, even as a life study, it seems to suggest a tragic narrative involving vulnerable humanity.

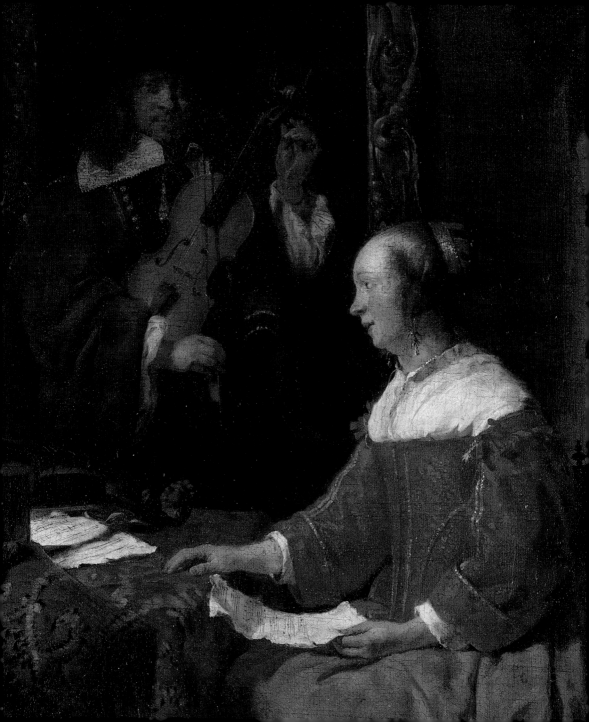

GABRIEL METSU
Leiden 1629–1667 Amsterdam

*A Woman seated at a Table and a Man tuning a Violin*, c.1658

Oil on canvas, 43 x 37.5 cm

Purchase, 1871

NG838

WALTER PATER NOTED that we owe to Giorgione and his contemporaries in Venice the invention of 'those easily movable pictures which serve neither for uses of devotion, nor of allegorical or historical teaching – little groups of real men and women, amid congruous furniture or landscape – morsels of actual life, conversation or music or play, but refined upon or idealised, till they come to seem like glimpses of life from afar'. In the Venice of Giorgione, such pictures were often pastorals with an outdoor setting. A hundred and fifty years later in Holland they were usually interior scenes, and of this class of painting there are a dozen fine examples in the National Gallery, among which this is perhaps the most beautiful and the most poetic, being free of gross humour or tiresome innuendo or obvious moralising. The unusual colour scheme – with beautifully spaced patches of white setting off pinks and orange – is as inviting as a log fire, and although Metsu is a master of miniature effect he knows how to refrain from tiring the eye with detail, leaving, for example, the pattern of the table carpet illegible. But we enter a world in which the human beings, to the perplexity of the spaniel, are partly absent: the man, almost contained within the picture frame behind him, frowns as he listens to the instrument he is tuning, while the woman gazes into a looking-glass, perhaps thinking of the past or the future, letting a sheet of music drop to her lap (for reflections stimulate reflections no less than music does). The curve of that sheet is beautifully related to the curve of her sleeve, her arm leads us to her profile which is perfectly placed between straight and curved lines, while her colouring combines the pink and orange and white.

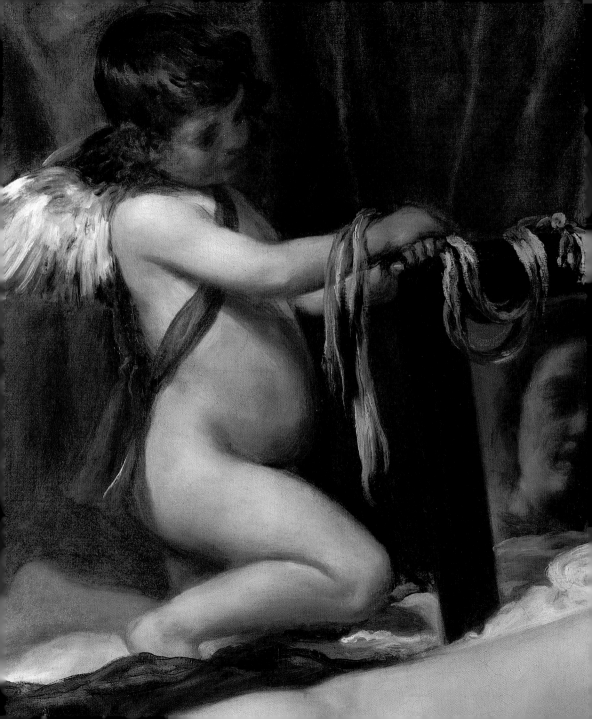

DIEGO VELÁZQUEZ
Seville 1599–1660 Madrid

*The Toilet of Venus ('The Rokeby Venus'),* 1647–51

Oil on canvas, 122.5 x 177 cm

Presented by the Art Fund, 1906

NG2057

BECAUSE VELÁZQUEZ'S *'Rokeby Venus'* is so familiar that it is hard to look at it with fresh eyes, I have chosen to concentrate on one part of it. The detail illustrated here shows the kneeling Cupid holding a looking-glass for a nude woman to gaze into. Without the presence of Cupid we might not be sure that she is Venus. His wings, painted with about 20 long and short

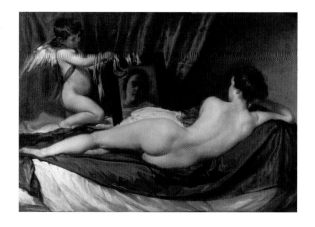

strokes, repeat the whites and greys of the sheets upon which his mother reclines. Presumably the blue sash is for his quiver. The pink ribbon is used to hang the glass on the wall. Cupid's belly answers the curves of his mother's body, those not only of her buttocks but of her calf, which his own lower leg so beautifully echoes. The way the straight edge of the slanting frame contrasts with, and thus emphasises, his belly and is repeated in his back (helped by the shadow of the blue sash) is especially satisfying – more so than any purely formal arrangement can be. Cupid seems delighted by his mother's beauty, and by her delight in her own beauty, and this is conveyed by his posture, by the angle of his head as well as his features, painted very thinly, very softly, so that the edges almost disappear on close examination. The apparent ease of such painting is remarkable; the breathtaking economy of means is even more so.

GEORGE STUBBS
Liverpool 1724–1806 London

**The Milbanke and Melbourne Families**, *c.*1769

Oil on canvas, 97.2 x 147.3 cm

Purchase, 1975

NG6429

THIS IS AN EXAMPLE of a class of painting which is known
as the 'conversation piece' – although in this case any
sociable exchange seems to be silent. We would easily
guess that the young woman and the older man on the left
are father and daughter, and we might suppose that the
two young men are her brothers. In fact, the mounted
gentleman is her husband. It may seem odd that there is
so much space between the married couple, yet everyone
– including the three horses and the spaniel – appears to
be equally at ease. It is characteristic of Stubbs to avoid
overlaps in the elements of the composition, such as the
three horses here, which he must have studied separately.
This distinct treatment of each part reinforces awareness
of the careful balance between them. The landscape is
painted like a stage curtain that serves a foil for the pre-
cisely rendered figures arranged before it. The mighty
oak and distant crags hint at the ancient lineage of the two
families and the part of Derbyshire that they owned. The
very quiet pink of the woman's dress is unostentatiously
picked up in the hollyhocks on the right. There is no flam-
boyance in the handling of the paint but, instead, a
gracious assurance. Harmony prevails, embodied in the
aesthetic values no less than in the polite manners.

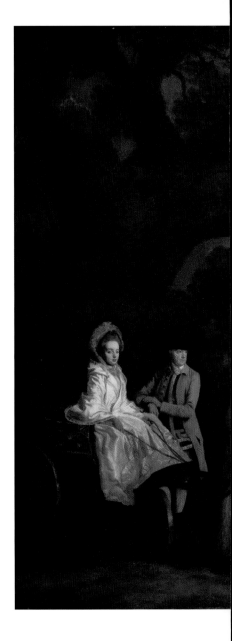

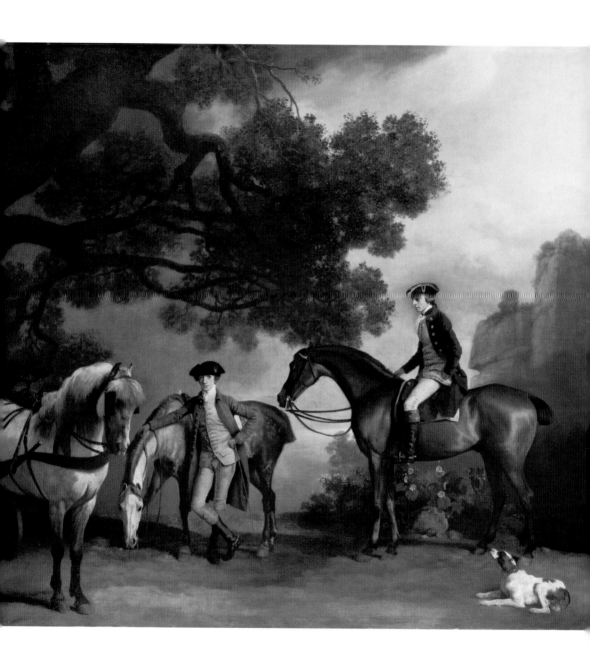

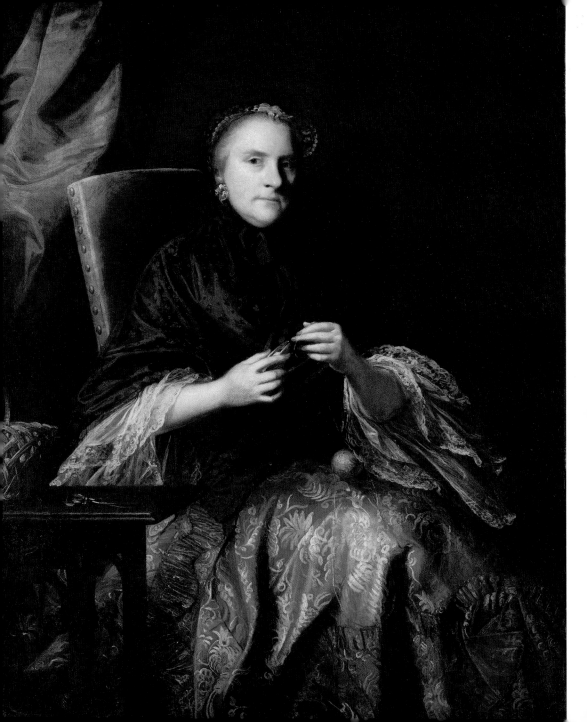

*Anne, 2nd Countess of Albemarle*, *c.*1760

Oil on canvas, 126.5 x 101 cm

Purchase, 1888

NG1259

LADY ALBEMARLE was the mother of a friend of the artist and thus a woman better known to him than were most of his other aristocratic sitters. Her personality is vividly suggested by her critically attentive expression, made more intense by her pallor, which is now greater (on account of the fading of the pigment, red lake) than the artist can have intended. The dress is painted with some bravura and with no attempt at precision in the depiction of lace sleeves, earrings or the embroidery on the shawl, which reads as both black on grey and grey on black. Reynolds disparaged the meticulous delineation of facts, preferring to emphasise the more imaginative aspects of painting. This may seem surprising in a successful portraitist, but it is probably true that he was more accomplished at capturing a characteristic expression, or inventing an appropriate one, than he was at recording idiosyncratic features. Reynolds began his career in the workshop of Thomas Hudson, a mediocre but successful portraitist, and never received proper training as a draughtsman. When he travelled to Italy he may have envied the academic accomplishments of the leading painters there, but he also recognised a formulaic component to their art, exemplified by the graceful attitudes of the often interchangeable hands in portraits. Lady Albemarle's hands are somewhat wooden, and drawn with evident effort, but they are eloquent, pausing as they do in their knotting as she follows the thread of a conversation.

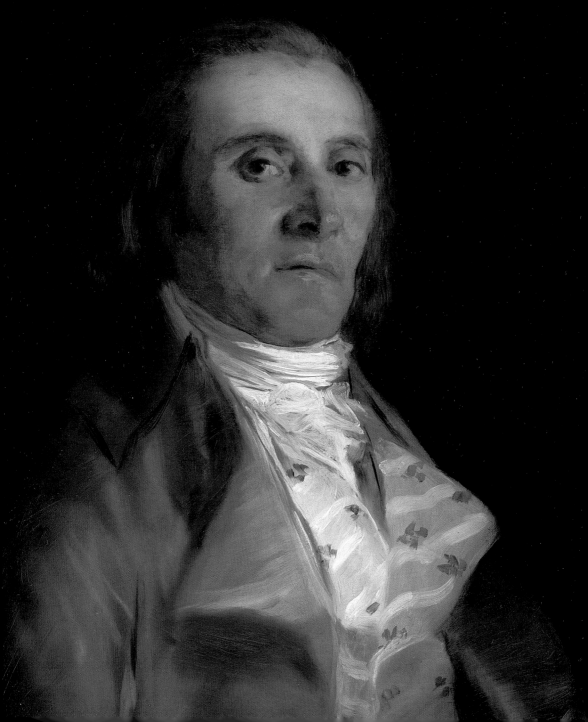

## Francisco de Goya
Fuendetodos, near Saragossa 1746–1828 Bordeaux

### *Don Andrés del Peral*, before 1798

Oil on poplar, 95 x 65.7 cm
Presented by Sir George Donaldson, 1904
NG1951

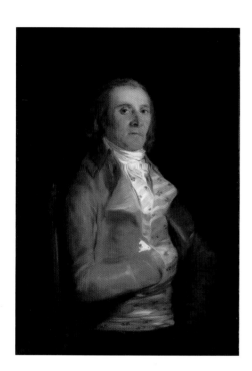

THE BACKGROUND is black – a smooth black – because the portrait was painted on panel rather than canvas, which by the eighteenth century was the usual support for European paintings of this kind. The chair-back is rendered with six rapid strokes, the trousers are hardly indicated at all, the grey of the hair and jacket seem to emerge from the background, giving the portrait the feeling almost of an apparition. To me it seems unlikely that Goya used any preparatory drawings, whether on paper or on the panel itself. The relation of the arms to the body is uncertain, although the angles they establish are eloquent. It is hard to believe that the sitter is actually sitting. His head is tilted back and in his expression there is a mingling of flinching vulnerability with apparent disdain. It is usual for people in Goya's portraits to seem somewhat ill at ease – although this quality is notably absent from the portrait of Doña Isabel de Porcel hanging nearby (NG1473) – whether they were nobles or, as is the case here, a fellow craftsman. Portraits that seem almost to speak have always been especially admired, and here the parting of the lips below the visible nostril – even if reflecting the vestiges of an attack of palsy – gives that effect.

EDOUARD MANET
Paris 1832–1883 Paris

## The Execution of Maximilian, c.1867–68

Oil on canvas, 193 x 284 cm

Purchase, 1918

NG3294

MANET WAS AWARE that the agenda of realism had removed many traditional subjects from the artist's reach, including sacred icons and narratives, and moral and political allegory, but he wanted to record some of the major historical events of his own day, such as the execution by firing squad of the Hapsburg ruler placed by France on the throne of Mexico. He did not consider the composition to be a success and probably began to dismember it, a process that was continued after his death. Degas salvaged fragments for his own collection, and in 1992 the National Gallery decided to reassemble these. The result, though much appreciated, entailed a loss as well as a gain, for it has become difficult to consider the officer loading his rifle as a separate work. And, yet, although deplored as mercenary vandalism, this conversion of a fragment into a self-contained composition was highly characteristic of artistic practice at that date.

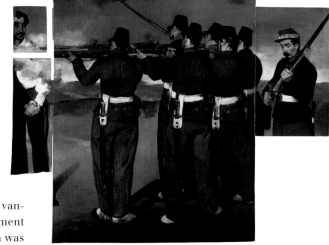

As a boldly simplified pattern of black, white, red and blue confidently brushed in creamy paint it is more compelling than any other portion of the original painting – or any reconstruction of the artist's ambitious idea.

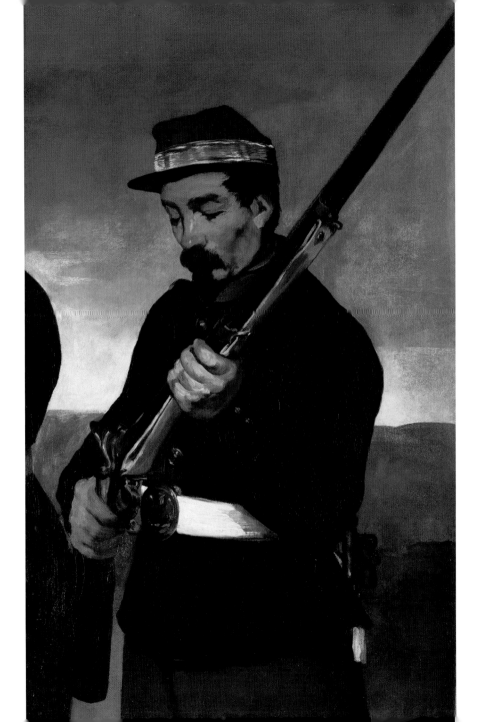

Georges Seurat
Paris 1859–1891 Paris

**Bathers at Asnières**, 1884

Oil on canvas, 201 x 300 cm

Purchase, 1924

NG3908

This is the only painting in this anthology that I always approach with mixed feelings. It is far easier to admire than enjoy, and nearly all the pleasure it gives me is confined to the left-hand side, illustrated opposite.

Seurat wanted to invest painting with the authority of modern science, especially in the representation of light, and to adopt in his art a whole range of other academic disciplines. He himself is regarded as a hero in the genealogy of modern art and this discourages an objective assessment of his actual success. His drawings have a mesmerising beauty, as do some of his landscapes, perhaps especially those of a crepuscular character, and his stationary figures, like the four here who are resting in a variety of poses that are wittily related to the angles of the bank or to the curve of a sail and to each other, like a complex rhyming scheme, are highly effective when they furnish a landscape. But the large figure Seurat added to right of centre not

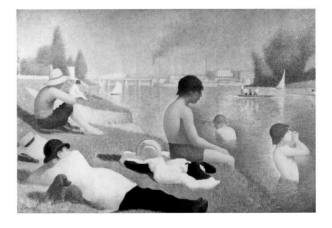

only throws out the spatial scheme but gives a pre-eminence to someone who is not only inert but dumb, even glum. Previous attempts to concentrate on essentials in painting (such as Poussin's; see pages 54/55) were made in the interests of eloquence and of clarifying action. This apotheosis of the inarticulate seems more appropriate for satire.

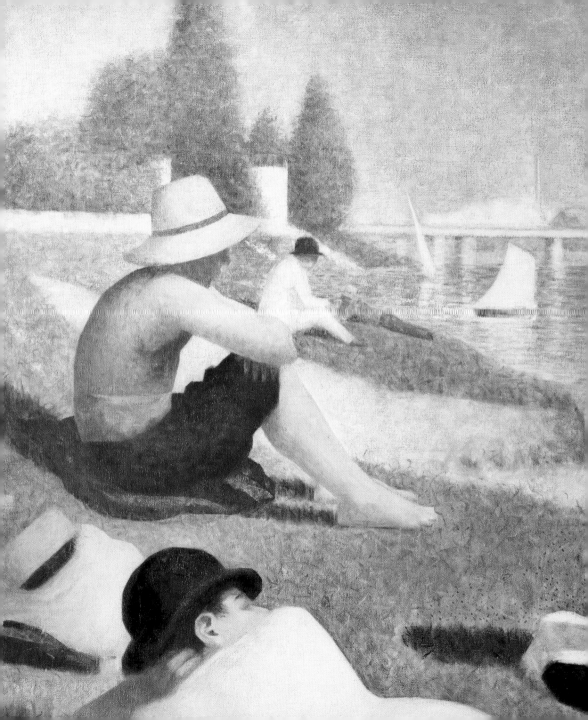

CLAUDE MONET
Paris 1840–1926 Giverny

*Water-Lilies, Setting Sun*, *c.*1907

Oil on canvas, 73 x 92.7 cm
Bequeathed by Simon Sainsbury, 2006
NG6608

THIS PAINTING represents the surface of the pond at Giverny in
Normandy, where Monet lived for most of his old age. Other
than the water, lilypads and reeds are the only things which are
depicted, the former suggesting recession by their diminishing
size and the latter indicating the viewer's position on the bank.
All else is reflection: the setting sun on the left side, the weeping
willow on the right, other trees. At what is usually considered a
normal viewing distance large trails and dabs of paint, some of
them perhaps smeared with a finger on top of layers scraped
with a knife or rubbed with a cloth, vie for our attention. It is
only at a distance of six feet or more that we are able to grasp
what is being represented. Impressionism, a movement that
was devoted to painting the familiar, with an emphasis on light-
effects, has developed here into a way of making the familiar
seem strange, with reeds growing in the same direction as
falling willow branches, the sun rising at the top of the paint-
ing, the distant sky floating on a near surface. It reminds me of
Alexander Pope's *Windsor Forest*, written 200 years before, in
which a shepherd finds upturned hills and 'downward skies' in
the river Loddon – 'And absent trees that tremble in the floods'.

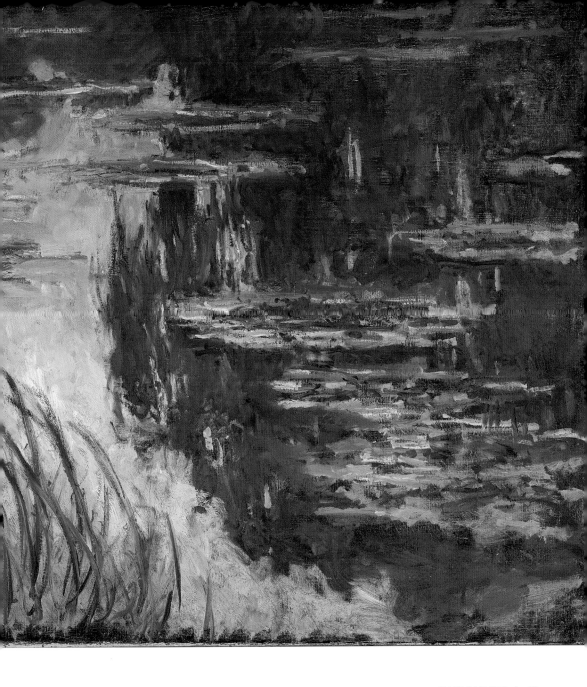

EDGAR DEGAS
Paris 1834–1917 Paris

*Combing the Hair ('La Coiffure'), c.*1896

Oil on canvas, 114.3 x 146.7 cm

Purchase, 1937

NG4865

THE GREATEST ARTISTS of the late nineteenth century developed an aversion to pictorial invention as it had been previously understood. They were reluctant to employ fanciful allegorical language (although the style and subject matter of Tiepolo did enjoy some favour, as can be seen in what is now the restaurant of the Musée d'Orsay), and turned their backs on such subjects as the Toilet of Venus and the Adoration of the Shepherds. Degas began his career as a painter of compositions taken from history, such as *Young Spartans Exercising* (NG3860), but soon turned to documenting modern life. Gradually, however, accessories came to matter to him less and less. In this everyday scene he gives little attention to the clothes and no attention to the setting, merely hinting at a curtain and a picture frame and providing only a summary outline of the table.

Degas was a tireless student of the body in movement but the actions he records are not heroic and indeed are often routine and mindless: women fasten their shoes, press down on their irons, twist to dry themselves, brush their hair or, as here, that of their mistress. The involuntary gesture also interested him, exemplified here by the seated woman's raised left arm. The diagonal of the composition, extending across the canvas and into space, is managed with the skill that we admire in Veronese (see pages 38/39) but it is also an astonishingly accurate record of the mundane but complex physical and psychological interaction between two figures in the real world.

The handling of the paint is rough, with a broad but broken outline, and patches of bare canvas. Such roughness, evident throughout Degas's career but especially marked in his late work, suggests the imperfect concordance of contour and colour, the shifting of form in and out of focus, the solid world constantly

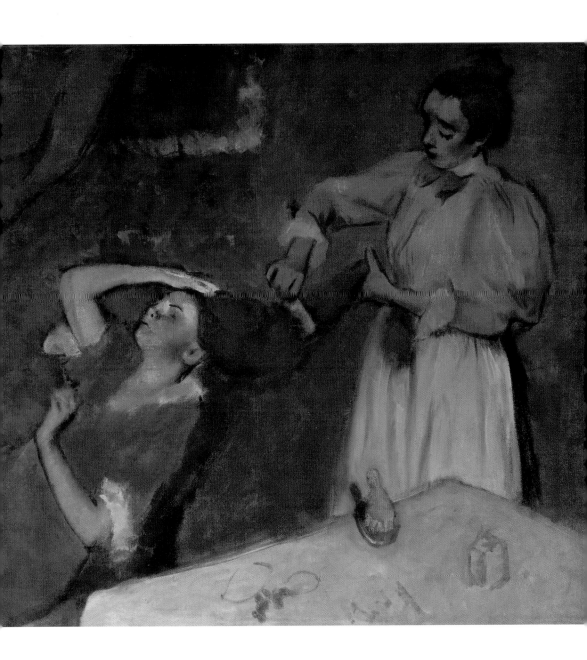

threatening to slip away. This aspect of Degas's painting may have had some connection with his eyesight, which was far from normal, but it is also significant that he took a keen interest in photography, an art that he himself practised. Whereas other artists tried to emulate the often metallic sharpness of objects in the foreground of a photograph, Degas seems to have been attracted by effects of flattening and smudging, as can be seen (above) in his painting, *Princess Pauline de Metternich* (NG3337), made more than 30 years before this one, from a *carte de visite* daguerreotype.

This edition © Scala Publishers Ltd, 2011
Text © The National Gallery Company Limited
Illustrations © The National Gallery, London, except page 30:
The Metropolitan Museum, New York, lent by the French Republic,
Ministry of Foreign and European Affairs

First published in 2011 by
Scala Publishers Ltd
Northburgh House
10 Northburgh Street
London EC1V OAT
www.scalapublishers.com

In association with the National Gallery, London
www.nationalgallery.org.uk

ISBN: 978 1 85759 641 0

Editor: Sandra Pisano
Designer: Nigel Soper
Printed in Singapore

10 9 8 7 6 5 4 3 2 1

FRONT COVER: Titian, *Noli me Tangere*, c.1514 (see pages 14/15)
FRONTISPIECE: Jan Weenix, *An Italian Courtyard*, 1660–65 (see pages 56/57)
BACK COVER: Carlo Crivelli, *Saint Michael*, c.1476 (see pages 26/27)